PRAISE FOR *ART FOR ALL AGES*

"*Art for All Ages*'s purpose is to go beyond the mechanics of creating art to fire up the inspiration that promotes it in the first place. This approach places Corinne Miller Schaff's book in a category of its own…. This opportunity for a shared learning experience on equal grounds is rare, indeed, making *Art for All Ages* especially highly recommended for parents, kids, and any adult seeking supportive manuals not just for art, but for self-discovery and growth experiences that overcome age-related barriers."

> —*Midwest Book Review*, D. DONOVAN, Senior Reviewer

"A valuable resource for learning or renewing your art skills. The author offers exercises based on decades of experience as an art teacher, combining education with inspiration. With the book as a guide, my granddaughter and I enjoyed painting watercolors together. Cori Schaff makes the fundamentals fun."

> —Carol Strickland, PHD, author of *The Annotated Mona Lisa: A crash course in Art History from Prehistoric to Post-Modern*

"Painting and art making offer to each individual the ability to go within and discover new wellsprings of possibility and hope. Art for All Ages is a brilliant resource for anyone wanting to explore art making as a tool for meditation and personal growth—and so much more!"

> —Whitney Freya, author of *Rise Above, Free Your Mind One Brush Stroke at a Time*. WhitneyFreya.com

"After a long career in government and politics, through *Art for All Ages*, I discovered my inner artist. I learned I can express myself through Art and be proud of the result."

> —JoEllen, Chief of Staff to CA State Assemblymember

"Beautifully crafted and illustrated, *Art For All Ages* can be shared by parents with their children, teachers with their students, and the self-motivated but often intimidated as to how to begin making art. Filled with interesting art history, art facts, and anecdotal humor; this book is welcoming to artists at all skill levels."

> —Tom Lamb, MFA Photography, Rhode Island School of Design, BFA Printmaking, Hartford Art School. Lambstudio.com

D1066945

ART
FOR ALL
AGES

ART FOR ALL AGES

Reignite Your Artistic Self

CORINNE MILLER SCHAFF

Edited by Doug Schaff

Top Reads Publishing, LLC

Vista, California

Copyright © 2019 by Corinne Miller Schaff

All Rights Reserved. No part of this publication may be reproduced, stored in or introduced into a retrieval system, or transmitted in any form or by any means (electronic, mechanical, photocopied, recorded of otherwise), without the prior written permission of both the copyright owner and the publisher of this book, except by a reviewer who wishes to quote brief passages in connection with a review written for insertion in a magazine, newspaper, broadcast, website, blog or other outlet.

First Edition

ISBN: 978-1-970107-03-6 (paperback)
ISBN: 978-1-970107-10-4 (ebook)

Library of Congress Control Number: 2019913173

ART FOR ALL AGES: Reigniting Your Artistic Self is published by:
Top Reads Publishing, LLC
1035 E. Vista Way, Suite 205, Vista, CA, 92084-4213 USA

For information please direct emails to:
teri@topreadspublishing.com

Cover artwork: Corinne Miller Schaff
Cover design: Teri Rider
Book layout and typography: Teri Rider & Associates
Interior artwork: Corinne Miller Schaff unless noted otherwise.

Printed in the United States of America

Dedication

For my parents Betty and Reid Engelmann
who have constantly believed in me.

Doug Schaff, my best friend, husband and editor.

My sons, Clark and Reid. My sister Anne.

My true-blue friends across time. You know who you are.

All the students I have had the privilege of teaching.

Contents

Use these symbols to easily find activities suitable for your group.

■ Adults with Adults of Any Age: *Baby Boomers, Millennials and Young Adults*

▲ Adults, Teens and Upper Elementary: *Age 10 and up, especially if that is chapter in your life where you lost your zest or had fear of artistic realism!*

● Lower Elementary: *Ages 6-10*

★ Little Ones: *Age 5*

Preface & Intentions

"Every child is an artist.
The problem is how to remain an artist once we grow up."
Pablo Picasso

My passion has been to ignite the creativity and artistic abilities of those I have had the privilege to teach. My intention with this book is to make the same experience available to you in fun, "user-friendly" ways.

I'm not an artist. I can't even draw a stick figure.

Have you ever had such thoughts? Throughout my 35 years of teaching I've heard similar frustrations, from young students and high school athletes to my 71-year-old neighbor, attorneys and others at art gatherings in my studio. All were initially held back by pre-conceived notions of what their art "should" look like.

I unconditionally know that each of us has inherent artistic ability. Nothing satisfies me more than seeing these same students beaming at their just completed artwork.

Drawing skills can be learned at any age.

My promise to you is that, *no matter where you are on the artistic scale*, by following the process and accomplishing the activities in this book, you will:

- Tap into your artistic self
- Discover your own style
- Enjoy creating accomplished art

If you are a creative artist, this book will deepen the sense of joy you get from making art. If you are new to art, I invite you to experience and enjoy the process.

FULL DISCLOSURE: Benefits along the way will likely include reduced stress and occasional feelings of wonder.

Art for All Ages is the *only* book that provides exceptional how-to art instruction while also nurturing and guiding the holistic experiences available to anyone making art in this way.

Experience the everyday miracle available within these pages. Creating art calms the mind. At times, a sense of adventure draws us into the moment. Just as exercise physically activates endorphins that reduce stress and make us feel great, making art in the way presented can produce a similar experience that I call the *Pizazz of the Heart*.

The book is organized in three mutually supportive parts, as follows:

Self-Discovery Vignettes

Self-Discovery pieces are scattered throughout, such as "The Art of Aging" and "The Universal Age of Symbols." Some are fact-based, like "Harmony of the Brain" which invites you to the awareness that you are inherently creative and artistic. Others are more inspirational, like "Mindfulness, Meditation & Art," which describes the energized focus and feelings of reconnection that you can experience while making art.

Art for All Ages is designed to be interactive and multi-generational, with offerings of art experiences that can be shared with young and old, siblings, support groups, best friends, children with parents and grandparents, couples, adult friends, as well as seniors. While each activity can be done alone, the full benefits emerge in an interactive group.

See the vignette called *How to Throw an Art Party*. Art Parties encourage socialization with friends and varied age groups. Sharing the step-by-step art activities provides opportunities for inspiration and mutual support. From extensive experience, I assure you of rewarding times that will be remembered for years to come.

Essential Ingredients

Each Recipe for success calls for its own *Essential Ingredients*, one or more art skills that you will use to complete the Recipe's activity. Adults or adults with children can dive into the book at any point to find inspiration, choose activities and acquire skills in easily accessible ways.

I created over 100 illustrations specifically for this book, so that you will have the same success as if you were with me in my classroom or studio.

Recipes for Success

The activity lessons in *Art for All Ages* are time-tested—selected from the visual curriculum that I developed over 35-years teaching art in public schools and privately to adults and multi-generational groups of all ages. *This is not a paint-by-numbers book!* Art history is an important component, seamlessly woven into the activity lessons. A "Reflection Zone" follows each activity to capture your impressions and evaluate new-found knowledge.

A Note to Grandparents, Mentors and Parents

The Table of Contents highlights lessons particularly suited for various age-levels. That said, you will find the book's activities can be adjusted for budding artists of all ages. All are suitable for adults. Multi-generational "do-a-longs" are encouraged. Adults doing the activities with children will experience joy and a child-like freedom. Click your heels; Go back in time. Share this gift with those you care about most.

He is currently an investment banker.

Chapter 1

Decision Stage

Pseudo-Realistic

Schematic

Dawning Realism

The Capable Artist who can render realistically ignites to create their own style

Preschematic

The Scribble Stage

Adult standards set in and artists stop growing Life gets filled with other activities

Where Are You On The Artistic Scale?

Pick Up Where You Left Off

Start where you left off. Get back to the art scale.
Join Art For All Ages

The aged with fine motor loss or cognitive impairment enjoy kinesthetic art experiences along with storytelling

CHAPTER 1

WHERE ARE YOU ON THE ARTISTIC SCALE?
We all start out drawing stick figures.

Earlier in life many of us took on messages such as: "I'm not good at art," or "I'll never be an artist."

Adult standards set in. Life fills with other activities. Yet the messages remain, small but powerful building blocks of self-image that can limit our notion, even today, of what we can and can't accomplish.

That is until now.

The fact is that we all start off drawing stick figures. That's normal—to be expected. It's a developmental stage, as normal as babies crawling before they walk.

In 1947, Viktor Lowenfeld introduced the stages of creative expression that all artists go through.[1] His list, still a paradigm, is presented below.

Where are you in your artistic development? No matter where you are, I encourage you to see that stage as the place where you left off making art, learning techniques, and feeling comfortable about your art skills and your ability to make realistic art.

Note: Lowenfeld did not judge one as better than the next. Neither should you.

Ethan

The Scribble Stage

Marks are made for physical enjoyment. Later in this stage, children may put words with their mark. In the case of the aged, they may tell a story from the past based on their long-term memory.

Reid

Pre-schematic

We see connections between our world and the shapes we draw.

We begin to communicate through our drawings.

Christopher

Schematic

Schematic: a diagram, plan, or drawing[2]. You have order and clear shapes that communicate, for example: buildings, people, etc. The more important an object the larger it is.

Miranda

Dawning Realism

The order and structure of your art becomes more involved.

Understanding overlapping and a beginning sense of spatial relationship like foreground and background become evident at this stage.

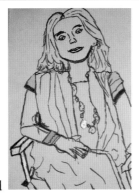

Diamond

Pseudo-realistic

This is the adolescent start of self-criticism, insecurity and fear of failure. Realism like value and shading, along with exact rendering is the basis for success at this critical point in our artistic development. Frustration sets in and many of us stop our artistic growth at this time … or put it on hold.

Arman

Decision Stage

This is the alert time when we are highly self-critical and will decide whether there is merit in continuing to draw. At this point with practice, good instruction, and encouragement, skills can be developed with successful outcomes.

Along the way while teaching art to "seniors", I found that even the aged with fine motor loss or cognitive impairment enjoy the experience of making art and may come full circle back to the joy of the scribble stage. (Let's call this abstract art!)

No matter what artistic stage you fall into now, you have an abundance of innate artistic ability that's waiting to be tapped. Start wherever you left off and ignite the creative forces within you.

1. Lowenfeld, V. and Brittain, W. (1947). *Creative and mental growth*. 1st ed. New York, NY: The Macmillan Company.
2. *Random House Kernerman Webster's College Dictionary*. S.v. "schematic." Retrieved June 7 2019 from https://www.thefreedictionary.com/schematic

THE UNIVERSAL LANGUAGE OF SYMBOLS

Art is non-verbal and cross-cultural. The universal language of all mankind is visual starting with early pictorial hieroglyphics and cave paintings serving as scripted pictorial language to allow the exchange of information.

In every language 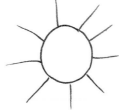 **says "sun"**

Many images together create sentences, whether they are Chinese characters or our Western alphabet. When learning a new language, tools like visual dictionaries confirm that a "picture paints a thousand words."

When we interact with people from foreign lands, facial expressions, body language, and tone of voice are all involved in communicating thoughts and feelings.

My sun lesson: *el sol*

Here is an opportunity to re-invent the sun. Once I have established a positive atmosphere and a comfort level with my students, I offer them the opportunity to re-invent the sun.

First, I draw this.

Then I tease that the sun doesn't really look like this Spider.

Next, I ask, "How many of you have drawn this picture?" Even I raise my hand.

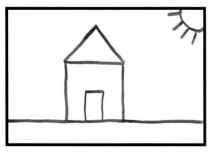

But this house would be on fire! Why?

Often, children add a line for the sky at the top of the page. Next, they add the chimney and the symbol for an apple tree filled with apples.

What is in this empty space?

Is it air?

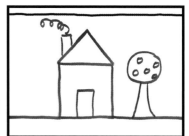

Don't the sky and the earth meet?

Where is the horizon line?

The sky and the earth meet at the
HORIZON LINE.

The sky and lake or ocean meet at the
HORIZON LINE.

Discussion:

The Sun radiates with rays reaching out to touch all of us.

What other circular objects can we think of that have rays extending out from the center?
A tire with spokes or the inside of a flower…
Look at your eye in the mirror or at a friend's eyeball.

RE-INVENT THE SUN ACTIVITY

Instead of calling it a sun, I will use the word MANDALA which in Sanskrit means circle.

Supplies:

- 8" x 8" or 10" x 10" square white paper
- black water base marker

1. Draw one circular mandala at a time. Place the 1st circular form off center. It will be larger and closer. Add rays and designs extending from the center.

2. Draw a second mandala behind the first (overlapping). Add rays and repeated designs. Each circular form will have different rays and designs.

3. Draw a third circular symbol "bleeding off" the side of the square. When I talk about a "bleed off," it means the object is going off the edges or corners of the piece. Here are some of mine, but you invent your own.

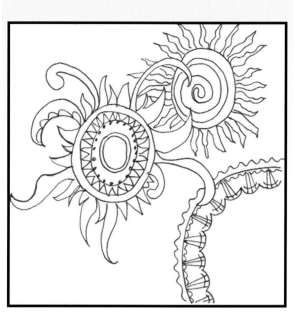

Your Turn: There is no right or wrong so Go Wild!

Remember to: • Bleed off the sides • Overlap.

CHAPTER 3

BRAIN FACTS AND YOUR INNATE CREATIVITY

Recent discoveries of how the brain works have upended traditional notions and triggered a new and growing appreciation for the innate creativity within each of us. We don't usually think of Science advancing Art. Yet, from schools to Silicon Valley, there is a growing recognition of the importance of the Arts in education and the workforce. These findings have profound implications for how we see ourselves and our world.

Two Halves Make a Whole
Left Brain / Right Brain

It started in the 1960s, when Dr. Richard W. Sperry showed that both the left and right hemispheres of the brain are each "hard-wired" at birth for different, specific groups of functions[1]. These innate abilities are distributed in a fascinating way between the two brain hemispheres. The left hemisphere houses abilities that we typically develop in school: verbal and organizational skills, time-based deadlines, rational thought, math, and more. The right hemisphere is home to feeling and emotional intelligence, intuition, big-picture thinking and other capabilities traditionally associated with creativity and the arts.

Abbreviated terms for the two hemispheres became popular, based on the functions located in each. The left hemisphere became commonly referred to as the "academic left brain," or simply the "left brain." The right hemisphere became known as the "creative right brain," or just the "right brain."

While the left and right brains house distinct functions, it would be a mistake to think of them as intrinsically separate. In between the brain hemispheres is the Corpus Callosum, a vast network of nerve cells that Sperry confirmed links the two hemispheres together.

Is it any wonder that Sperry's discoveries upended existing norms? What on earth would the rational mind need from the emotions? Quite a lot as it turns out, according to Neuroscientist Antonio Damasio and others. Damasio's research shows that emotions play a central role in decision-making[2]. In short, we need our emotions to make decisions, rational or otherwise.

I arrived at Stanford University in the mid-1970s to work on my Masters in Arts Education at a time when educators were obsessed with Sperry's discoveries and their implications for Arts Education[3]. I caught their enthusiasm.

"Harmony between both brain hemispheres is essential for all of us."
Corinne M. Schaff

We all need spatial awareness, a right brain function, to understand the relationship between ourselves and objects around us. A basketball player relies on their finely-tuned spatial intelligence when making

a split-second pass to a teammate between opposing players. This is true for athletes in all sports. Sailors, golfers, jockeys and runners must be visually and spatially aware.

Daydreaming is not typically looked at in a positive light. More often it's considered a time-waster or worse, the reason we missed our exit on the freeway. When you are creating art, daydreaming can be a sign that your creative right brain is fully functioning. It can inform your art. Isn't that wonderful?

My goal, when I teach is to call upon and develop both sides of the brain through the visual arts. Everyone, including lawyers and engineers can benefit from developing their creativity and learning to see. Silicon Valley increasingly values such skills. Apple's once unique combination of art and hi-tech has now become a required part of the formula. As a result, demand is rapidly growing for hi-tech job applicants with proven creative skills.

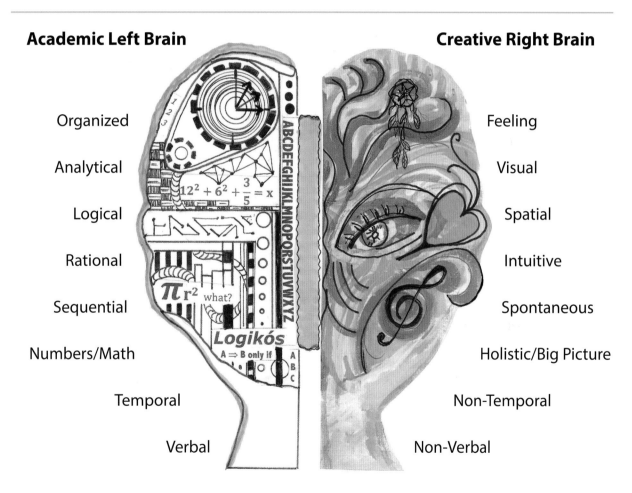

Academic Left Brain	**Creative Right Brain**
Organized	Feeling
Analytical	Visual
Logical	Spatial
Rational	Intuitive
Sequential	Spontaneous
Numbers/Math	Holistic/Big Picture
Temporal	Non-Temporal
Verbal	Non-Verbal

The Corpus Callosum
Connects the Two Hemispheres

Everyone has both sets of Brain Skills
With Harmony Balanced throught the Corpus Callosum

Upending Traditional Ideas

While the situation for arts education is slowly improving, math and science programs still receive the lion's share of resources. Why is it that society still places a premium on educating left brain skills?

To answer we go back to the time of Plato. His philosophy wouldn't matter except that Plato's teachings reverberate to this day. Good decisions, we are told, are rational, not intuitive. But is this true?

Einstein had a Broader View

Did Einstein rely exclusively on left brain abilities—such as logic and math—to develop his Theory of Relativity? Listen to the man and the answer becomes clear. Einstein valued creativity as much as reason. Einstein often linked a left-brain ability with a right-brain trait in a surprising way. He said:

"The true sign of intelligence is not knowledge but imagination." [4]

Albert Einstein

What is it about Einstein's words that surprises us? What gives us pause? It's not that he includes knowledge in his definition of intelligence. What's surprising is that he mentions imagination in the same breath. He did this so often that one wonders if Einstein was trying to tell us something very important.

Einstein vs. Plato

Plato's view of the mind has been disproved by Sperry, Damasio, and other scientists. Yet the world is still pulled by Plato's notion that reason is supreme. That can cause problems. We need our rational mind. Praising it excessively, though, can lead to harsh self-criticism that only serves to hold us back. This boils down to what I call the "shoulds and shits," recurring negative self-talk, as in "OMG, I should have done that," and "Oh shit, I didn't!"

Make no mistake; "Shoulds and shits" are the block between our head and our heart. That's why I recommend at the start of an art project, that you close your eyes, breath slowly, and open to a vision from the quiet of your mind. Don't let your bossy left brain tell you what you should do.

Though Einstein died before Sperry's Nobel Prize work was published, his view confirms what science has learned about our brain and how it works. He is a model for us. Einstein valued his whole brain, and used all his strengths, creative and rational.

What's needed is a balanced perspective that encompasses all of our strengths. Intuition can lead us astray, just as sole reliance on logic can produce impractical results. It's time to acknowledge that our best decisions, our best solutions, involve a combination of both feeling and reason.

1. In 1981 Richard Sperry shared the Nobel Prize in Physiology or Medicine with David H. Hubel and Torsten N. Wiesel.
2. "Faculty Profile USC Dana and David Dornsife College of Letters, Arts and Sciences." USC Dornsife College News RSS. Accessed January 3, 2018. https://dornsife.usc.edu/cf/faculty-and-staff/faculty.cfm?pid=1008328.
3. I completed my M.A.Ed. in 1976.
4. "Albert Einstein Quotes." BrainyQuote. Accessed December 12, 2017. https://www.brainyquote.com/quotes/albert_einstein_148802.

CHAPTER 4
ESSENTIAL INGREDIENTS

OUR COLORFUL WORLD: BASIC COLOR THEORY

PRIMARY COLORS

- red
- blue
- yellow

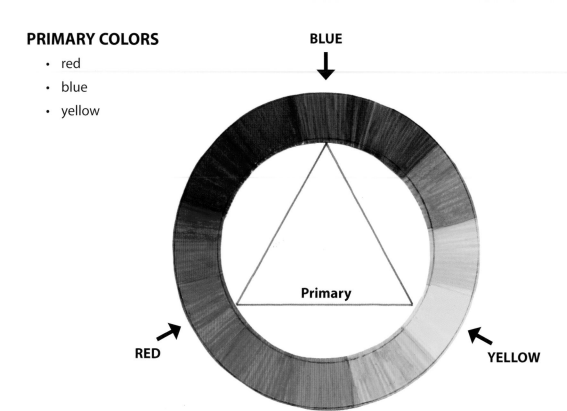

SECONDARY COLORS

The secondary colors green, orange, and purple can be made from the primary colors.

- red and blue make purple (violet)
- yellow and blue make green
- red and yellow make orange

TERTIARY COLORS, may also be referred to as Intermediate Colors

The tertiary colors are created by mixing a primary color with the secondary color next to it on the color-wheel.

Look at all of the different greens between blue and yellow.

The colors on the color wheel between a primary and a secondary color make the **TERTIARY Colors.**

- red-orange
- red-violet
- blue-green
- blue-violet
- yellow-orange
- yellow-green

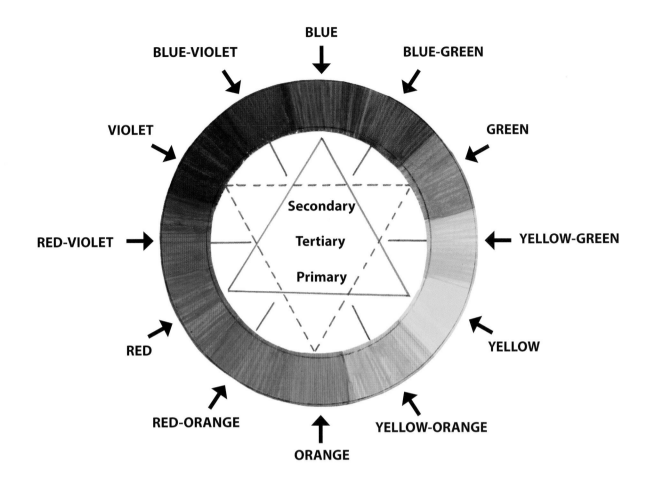

MORE COLOR VOCABULARY

ANALOGOUS COLORS are next to one another on the color wheel.

COMPLIMENTARY COLORS are opposite/across from one another on the color wheel.

Do you see black and white on the color wheel?

BLACK AND WHITE ARE NOT COLORS

Technically white is pure light and black is the absence of light.

Black and white added together make grey.

Black or white can be added to a color to create a **TINT or SHADE.**

TINT or SHADE

- Tint means adding white to a color. To remember, think the word tint and white both have an "i."

- Shade means adding black to a color. The word shade and black both have an "a."

MONOCHROMATIC

"Mono" means one and "chrome" means color. One color may be mixed with *either* white or black to create values of that color.

You can have a painting in just blues, like Pablo Picasso created.

CREATING NEW COLORS WITH PAINT

MIXING TEMPERA OR ACRYLIC PAINT

Use lots of paper plates. Have a pile of paper towels ready to continually clean and dry your brush.

Try using a #8, #10, or #12 round brush depending on the size of the painting. See the Supplies List at the back of the book.

BRUSH CARE

Please don't MASH your brushes while mixing new colors. You have an investment in brushes, so you need to treat them with respect.

- Always clean and dry your brush and re-form the point.
- Don't tap-tap on the water container like a woodpecker or your colors will splat onto your beautiful work.
- It is not good to leave brushes in water or let them sit in paint.
- Think of acrylic paint as liquid plastic. When it dries, it is hard.

When setting up your palette, Place the three **PRIMARY** colors in a triangle:

- red
- blue
- yellow

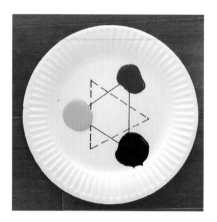

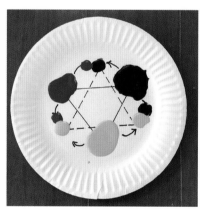

If you reviewed the Basic Color Theory, you will remember, the **SECONDARY** colors green, orange and purple can be made from the primary colors. This looks just like a color wheel.

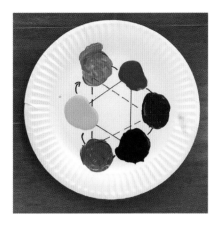

TERTIARY COLORS are the colors created by mixing a primary color with the secondary color next to it on the color wheel.

COMPLIMENTARY COLORS are across/opposite one another on the color wheel.

TINTS AND SHADES

Have a second plate or palette with white so you can mix a color with white to create a tint, e.g., red and white make pink. The pink will get lighter with more and more white.

Black and white are not colors, but you will need them to make tints and shades.

Tint means adding white to a color. To remember, think the word t<u>i</u>nt and wh<u>i</u>te both have an "i."

Shade means adding black to a color. The word sh<u>a</u>de has an "a" and bl<u>a</u>ck has an "a."

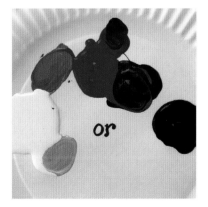

Add the following to your palette to get the most options for creating new colors.

- magenta
- turquoise
- if your budget allows, buy the secondary colors: orange, green and purple (by the way purple is violet)

PAINTING TIP 101: Never use a color right out of the bottle or tube. Change a bottled color in the slightest way to make it your own color!

Acrylic painters:

When painting with acrylics, you may initially lay down a more transparent color by adding more water to the color.

Acrylic colors are liquid plastic when they dry, so keep those brushes clean.

As your painting unfolds, it will strengthen with deeper **Opaque** (can't see through) colors.

Remember, after your artwork dries, you can always paint over something you don't like. The joy of paint!

ACTIVITY

HOW TO MAKE TINTS AND BROWNS

You will create browns by mixing 2 complimentary colors (opposite on color wheel).

You will also create tints using both the primary and secondary colors.

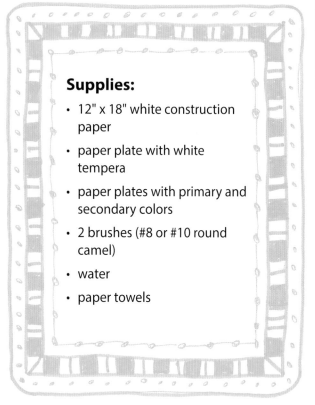

Supplies:

- 12" x 18" white construction paper
- paper plate with white tempera
- paper plates with primary and secondary colors
- 2 brushes (#8 or #10 round camel)
- water
- paper towels

To make the color chart:

1. Divide the 12" x 18" white construction paper to create a blank color chart, like the one below.

 You want your chart to have 18 shapes.

2. Use one brush for the blue and another for the orange.
 Starting at the top row, place blue in the 2nd space. Place orange in the 5th space. Leave the end spaces for adding white to create tints.

3. On your plate/palette, mix orange with a little blue. Paint your new brown next to the orange.

4. Mix a 2nd brown by adding a little more blue to the orange. Place your new brown next to the pure blue on the color chart. One will be lighter because it has more orange.

5. Clean and dry your brush, bristle up between each step.

6. Mix a little blue into some white to create a tint. You make a color lighter by adding white. Place it in the far upper left space. Clean brush.

7. Do the same with white and a bit of orange. Place it in the far upper right space.

8. Go to the bottom row allowing the top row to dry. Repeat the same process for mixing purple and yellows.

9. Once dry, finish the middle row using reds and greens

ACTIVITY:

Use complimentary colors to make browns. Add white to colors to make tints.

Creating Tints		Creating Browns		Creating Tints	
Blue & White Tint	Blue (no White)	Blue (no White) with a touch of Orange	Orange (no White) with a touch of Blue	Orange (no White)	Orange & White Tint
Red & White Tint	Red (no White)	Red (no White) with a touch of Green	Green (no White) with a touch of Red	Green (no White)	Green & White Tint
Yellow & White Tint	Yellow (no White)	Yellow (no White) with a touch of Purple	Purple (no White) with a touch of Yellow	Purple (no White)	Purple/Violet & White Tint

Look how many glorious browns you will create!

ACTIVITY

MANDALA COLOR WHEEL

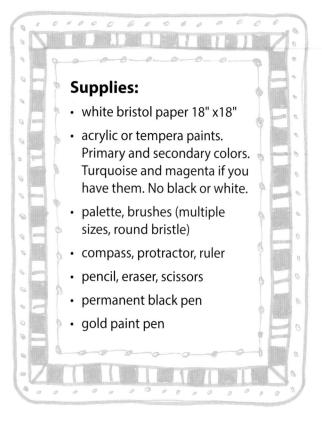

Supplies:

- white bristol paper 18" x18"
- acrylic or tempera paints. Primary and secondary colors. Turquoise and magenta if you have them. No black or white.
- palette, brushes (multiple sizes, round bristle)
- compass, protractor, ruler
- pencil, eraser, scissors
- permanent black pen
- gold paint pen

1. Look up "mandala" on the internet for inspiration

2. Measure 9" from all sides of the square to find the center. With pencil, gently make a dot for center.

 Draw a circle about 18" in diameter. As an option, you could trace a circle around the bottom of a trash can.

3. With a pencil, divide the circle into 12 pieces like a pie. If you have one, use a protractor to create 12 equal parts.

4. With your pencil and compass, make a few more internal rings.

 Create designs that radiate from the center out.

 Mandala is Sanskrit for circle and connection.

5. Using all of your knowledge of mixing paint, create all 12 colors:

 3 primaries, 3 secondaries, 6 tertiaries.

 You should be able to see primary, secondary, and tertiary colors when your color wheel is complete.

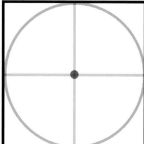

Once your mandala color wheel is totally dry, go over your initial pencil lines with permanent black pen.

If you have a gold paint pen, add some metallic pizazz.

Embellish the wheel with lines, circles and varied details.

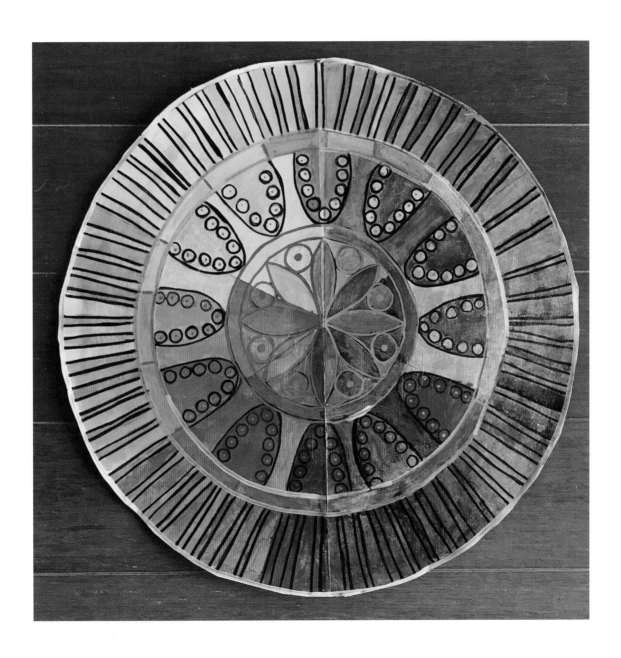

WATERCOLOR TECHNIQUES

Use watercolor that is **TRANSPARENT** which means you can see through it. Just like you need a little shampoo and a lot of water when you wash your hair, only use a little watercolor (pigment) and a lot of water depending on how transparent you want a color.

You can always make the color more intense by adding more paint pigment. When you overlay (add more color) on dry paint, the opacity (ability to see through it) changes.

You are working with **wet color**. Painting with watercolor is spontaneous. You cannot go back. Think of layering transparencies light to darker.

Never scrub the paper with your brush. If you don't have watercolor paper, you will possibly create a hole in your paper.

Just let the tip of your brush touch the paper. If needed, get more color to avoid going over and over an area.

If you want, use watercolor paper that you stretch with masking tape to a board or table. This keeps your paper in place and more even.

BRUSHES

Try a #8, #10 and #12 round affordable camel hair brush. If you can only buy one, a #10 will work. Once you get adjusted to all the glories of watercolor, you can explore the use of better sable brushes.

Try to get color on only the tip of your brush.

Please avoid twirling or mashing your brushes in the color pans.

WATERCOLOR PAINTS

For most purposes, 16 half pan Prang Semi-moist colors will work for all ages. See the Supplies List at the back of the book. If you are a semi-professional, a good set of tube water colors is a must.

- The 16 pan oval sets come with the turquoise, magenta, brown, black and white
- **Primary** colors: red, blue and yellow
- **Secondary** colors: orange, green and purple
- **Tertiary** colors are included in the 16 pan set. They are the colors created by mixing a primary color with the secondary color next to it on the color wheel: red orange, red violet, blue green, blue violet, yellow orange, and yellow green

Please take out the white pan because when painting with watercolor, the way to make a color lighter is to add water, not white. I often remove the black paint also. The only need for black is to create a gray.

Stay away from black and white with watercolor.

WARM UP

Prep: Put a large drop of water in each pan of watercolor to soften the paint.

Most watercolor sets come with a mixing tray or side palette where you can mix new colors.

Example: If you put yellow into purple, you will make brown as they are complimentary colors.

Try these techniques before you tackle a painting.

WATERCOLOR WASH

On watercolor paper, paint with a thin layer of water. Immediately add color, which will mix with the water to make a transparent color.

WET INTO WET

You can add an extra color that is close to the first color on the color wheel. Blue into violet and turquoise is grand, because they are analogous colors. Analogous colors are next to one another on the color wheel.

REMINDER: If you place a color next to another color while it is WET, they will mix, which could be a good thing or a bad thing!

Tip: You may use Kleenex® to pull up excess water. Don't blot.

WATERCOLOR RESIST

If you have soft clouds or other areas that you don't want contaminated with color, put a "mask/resist" down first to hold that area white. Art masking fluid is the standard for watercolor resist, but you may use the side of a white crayon, which will act as a resist to color.

DRY BRUSH

This is exactly as it sounds. Dip the brush in a concentrated color and dry the brush, bristle up, by squeezing or drying with a paper towel. Great for textures and details on already dried backgrounds. Try it.

DRAWING WITH PAINT

With a clean, dry pointed brush, you can make very fine lines of color, almost like drawing.

OVERLAY

Place pigment (color) on top of a dried, painted area to add detail.

WATERCOLOR TIPS

- Clean paint sets by wiping side palettes with a damp Kleenex®.
- If a color pan is contaminated, colors are easier to clean once dried so you won't waste paint pigment.
- Do not close your paint set.
- Leave sets open until they totally dry.
- It is best not to leave a brush in water.
- Clean and dry your brush bristle up.

ELEMENTS OF ART

Elements of Art are the tools used to create art.

VALUE - also referred to as TONE

The way and place that LIGHT hits
an object creates a shadow
and defines the object.
A light source gives objects
dimension.
The scale ranges from black to white.
The lightness and darkness of a color
creates contrast and an Illusion of depth.

TEXTURE

Surface feeling
Tactile implications in
2-dimensional art

COLOR - also referred to as HUE

Primary
Secondary
Tertiary/Intermediate colors
Complimentary
Analogous
Monochromatic
Warm and cool
Tints and shades

*Refer to Our Colorful World,
Essentials 1*

LINE

Variable width and length
A straight point moving through space
has direction.

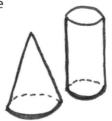

FORM

Shapes having height, depth, and width
appear to be 3-dimensional.

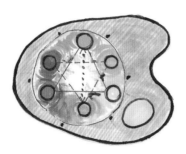

SHAPE

A closed line
The edge of a shape is
referred to as contour.
2-D has height and width,
no depth.
May be organic or geometric

SPACE

Illusion of depth
Appears 3-dimensional
1- and 2-point perspective create the illusion of depth.
Negative space is the area between and around objects.
Spatial relationship is the size of one shape in relation to another.

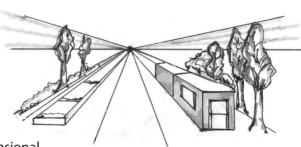

PRINCIPLES OF DESIGN

Principles of Design are the way the Elements of Art work together.

Proportion
involves spatial relationship and the size of one object compared to another.

Unity/Harmony
connects all parts of the piece to make it complete.

Variety
encourages interest from one area to another through the use of different shapes, sizes and colors.

Rhythm and Movement
The interaction of these principles is essential to creating a mood and direction so the artist or observer almost dances through a piece.

Pattern and Repetition
of Art Elements creates unity and intrigue.

Balance
in art is visual weight defined by symmetry or approximate symmetry. Symmetrical is when both sides have the same weight. Example: a butterfly. Asymmetrical is when the weight is heavier on one side.

Emphasis
or a strong focal point pulls the observer into the picture or a specific subject. The "Rule of Thirds" divides your piece and suggests that you place the object of interest on one of the 4 points, below.

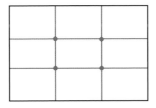

ESSENTIAL INGREDIENT 5

GAINING PERSPECTIVE
2D AND 3D ILLUSION OF SPACE

Perspective in art is a technique used to create the impression that objects are 3-dimensional on a 2-dimensional flat surface.

- Objects that are closer are lower on the canvas.
- Objects farther away are smaller and higher on the canvas.
- Colors of hills, for example, will be darker in the foreground and get lighter in the background.

OVERLAPPING

When an object is in front, we see all of it. When an object is placed behind, your logical brain knows it is all there. Only draw the part you see.

You will probably only see part of the **bottom** of the object in the back. Only draw what you see!

We do not see the bottom of the apple or the pear. So, do not draw them.

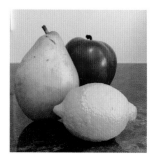 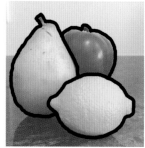

VIEWPOINT

Drawing from different viewpoints can make your composition more interesting.

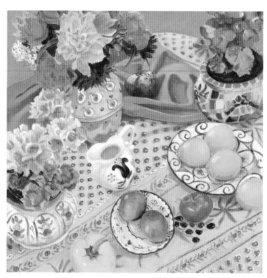

Matisse Morning II, Sallie Stanley, acrylic, SallieStanleyStudio.com

FORESHORTENING

An object recedes into the distance. The object appears shorter than it really is.

We **know** the "pointer finger" is long, but we **see** only the tip.

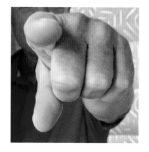

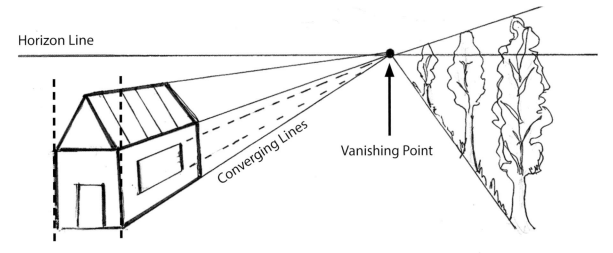

Horizon Line

Converging Lines

Vanishing Point

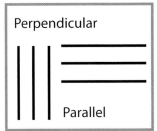

Perpendicular

Parallel

Converging lines go to the vanishing point on the horizon line.

DIFFERENT PERSPECTIVES

Where do you stand?

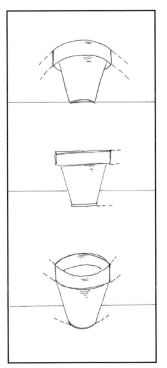

Looking From Below

Eye Level

Bird's-eye/Looking From Above

1-POINT PERSPECTIVE

In 1-point perspective, the horizon line is the line where the earth meets the sky.

It is always at your eye level (even if you squat down or stand on your head).

In 1-point perspective, place a vanishing point on the horizon line. Use a straight edge or ruler so all the lines of the tops of buildings, trees, etc., will go to the 1 vanishing point to achieve proper perspective. These are called **converging lines.**

Making Steps

To make steps appear 3-dimensioinal:

1. Draw the rectangular front of the steps.

2. Indicate vanishing point.

3. Draw plateau or top of steps using vanishing point.

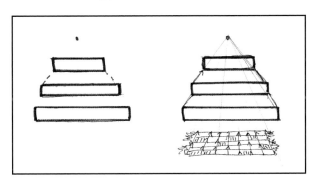

1-POINT PERSPECTIVE

Practice identifying the **vanishing point**, **horizon line**, and **converging lines** in this dramatic photo.

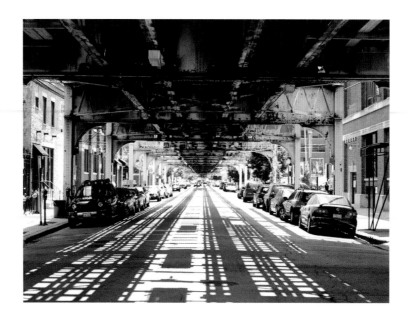

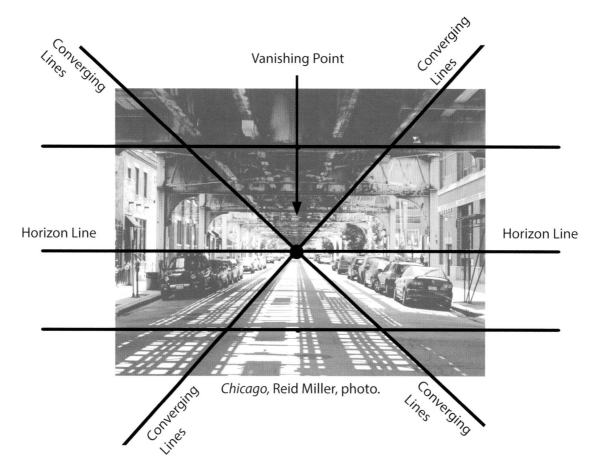

Converging Lines

Vanishing Point

Converging Lines

Horizon Line

Horizon Line

Converging Lines

Chicago, Reid Miller, photo.

Converging Lines

2-POINT PERSPECTIVE

Lines are either parallel or perpendicular to the top and sides of the paper.

Converging lines all go to the vanishing points on the horizon line where the earth meets the sky.

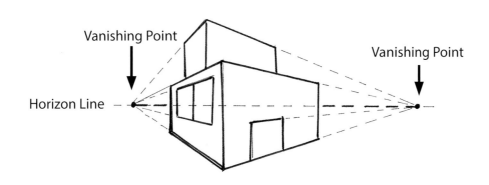

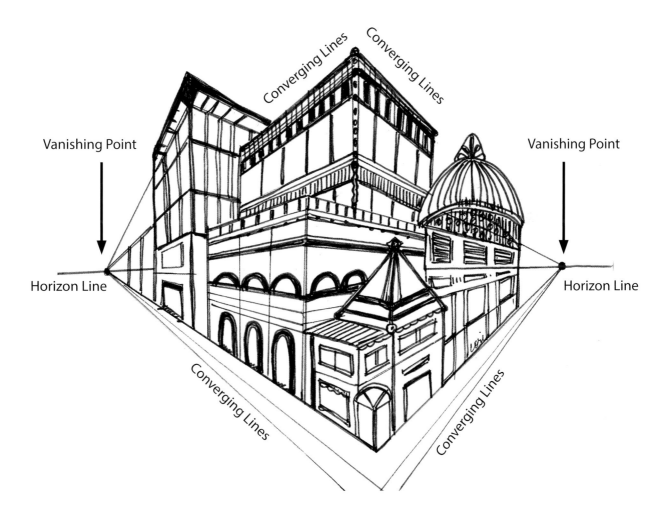

THE VALUES IN SHADING

The way and place that LIGHT hits an object creates a shadow and defines the object.

Volume

Just like in music, art ranges in intensity. Volume in art is the apparent bulk or mass of an object.

A round circle is a flat shape. It becomes three dimensional when it has mass.

Value

The shades of grey between black and white are referred to as values.Using values to show light and shadows makes an object appear three-dimensional. Adding values creates a sense of depth.

Values can also be made with a color by adding EITHER black OR white to the color.

Natural light from the sun will create a highlight and cast shadows.

Artificial light from a lamp or ceiling lights will create a highlight and cast shadows.

Without any light, images appear flat.

Light sources create **highlights.** When the light source hits an object, the object **casts shadows**. Cast shadows are formed when an object blocks the light.

Place an object in front of you. Notice the light source … where is the light coming from? From the sun or artificial light? Squint your eyes if needed. Where are the brightest whites? The brightest, lightest area of an object is referred to as the **HIGHLIGHT**. As a good observer you are really looking for the darks and lights.

The darkest side of the object is farthest from the light source. A shadow is created.

Shading

There are various shading techniques. Some are:

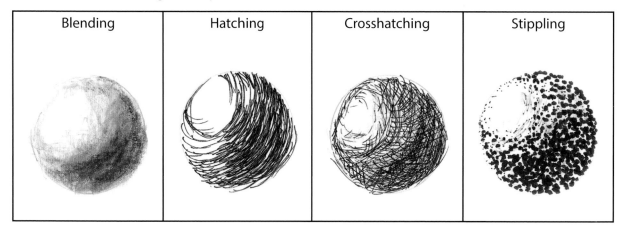

| Blending | Hatching | Crosshatching | Stippling |

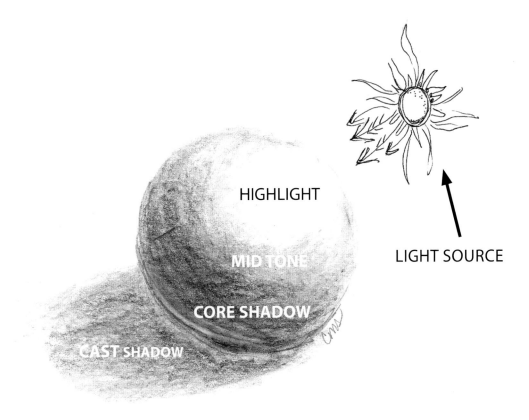

HIGHLIGHT

MID TONE

CORE SHADOW

CAST SHADOW

LIGHT SOURCE

For Fun

In total darkness, place a flashlight on the side of a white egg in the dark and you will see the HIGHLIGHT.

When drawing any landscape, portrait or still life, take some time to first sketch a few compositions in black and white. Select the best composition and then darken the shadows with values from the lightest of grey to black.

Refer to your black and white sketch when you add color, so you see the darks and lights.

THE BODY RECIPE
FIGURE PROPORTION, SIZE RELATIONSHIPS

Figure drawing may seem overwhelming, but it is easy if you understand the proportions. Adult figures are about 7 ½ heads tall. Sometimes we make the head too big, which makes the body out of proportion.

Be sure the shoulders are two heads wide. You are buff!

Arms are each approximately 3 heads long without the hands. Add the hands and notice where they hit your thighs.

What is your height?

If you are 5 feet tall, reach your arms, hands and finger tips out to the sides of your body. From the tips of one hand to the other is your height: 5 feet!

Demonstrate to one another.

Try it with a measuring tape!

From the top of your head to your waist is approximately 3 heads.

From the waist to the bottom of your hips is one head.

Your legs are 3 heads long (tall).

Add another ½ of a head size for your feet.

"Head count" for younger children varies:

Toddlers are about 4 heads tall, which is probably why children's first body drawings have large heads.

Young teens are about 5-6 heads tall.

Look carefully. Art is about learning to see.

Remember those first figure drawings?

How many heads tall are you?

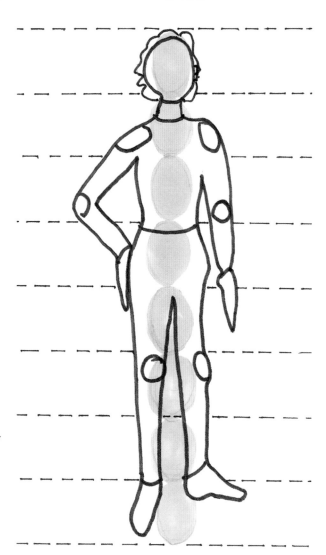

ACTIVITY:
Wood Mannequin Figure Drawings

Supplies:

- paper, white or soft gray
- pencil
- wood mannequin
- charcoal optional

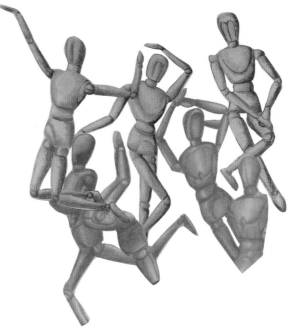

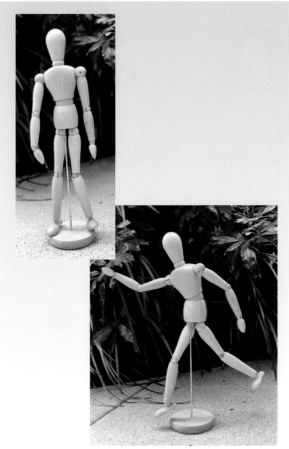

Draw a series of 5 wooden mannequins.

Pose each one into an action figure. They can even be turned on their heads.

You may choose to overlap legs and arms.

Create a composition of people interacting. You may even add chairs and other objects to tell a story.

Use your pencil or charcoal for shading. Decide where the light is coming from.

Create volume by using darks and lights to make figures appear three-dimensional.

ACTIVITY:

Gesture Drawings

A gesture drawing is a quick sketch of a figure.
No detail.
No outside contour lines.
Do not draw outside lines.
Do not draw stiff stick figures.

Gesture drawings show action, movement and rhythm.

These are loose scribble-like lines in motion.

An entire figure will take 30 seconds, and no more than 2 minutes.

Practice on a sketch paper using a thin black pen or crayon.

If you have a group, take turns modeling and drawing each other.

Models will be active, or frozen in twist and turns.

Start with the head, then the neck. Then fill in the body. Note the direction of the body. Scribble in the mass of the legs and feet positions. Add the arms. Think about the size-relationships, the proportion of the figure.

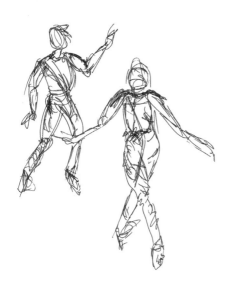

You may want to try gesture drawings that show more shape. Sometimes I call these mummy figures. The rules are the same. No outside lines and quick drawings.

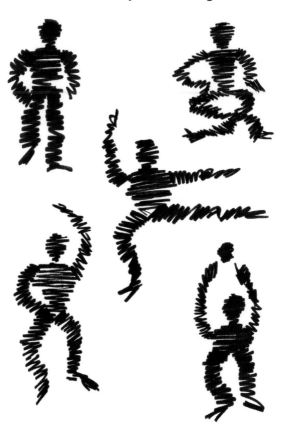

On a horizontal rectangular piece of paper, draw many figures.

Consider overlapping.

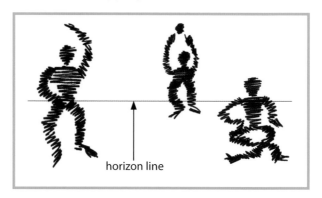

horizon line

Lastly, put the horizon line behind the figures to delineate foreground and background.

THE FACE RECIPE

Your eye shapes are in the middle of an oval head shape.

Put one hand parallel to the top of your head and the other hand at the base of the chin. Slowly move the top hand toward the eyes while you move the bottom hand upwards

You now realize the eyes are half-way in the middle of the head. There is a lot of brain covered by the hair!

There is one eye-width between your eyes.

The top of the ears are even with the eyes.

The base of the nose is even with the bottom of the ears.

The mouth is half way between the tip of the nose and the base of the chin.

The mouth is as wide as the center of the eyeball.

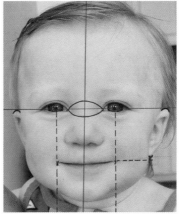

Thank you, Busy Lizzie!

Imagine an oval divided into fourths.

Look in a mirror

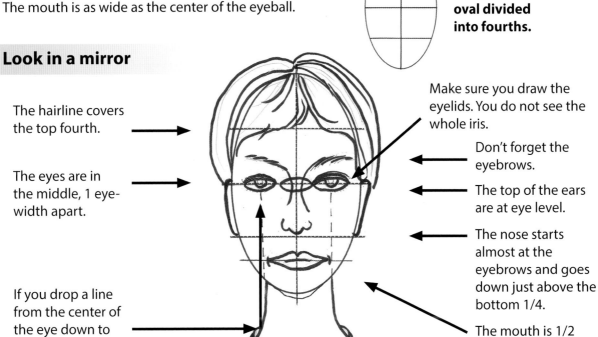

The hairline covers the top fourth.

The eyes are in the middle, 1 eye-width apart.

If you drop a line from the center of the eye down to the shoulder, that is the width of the neck.

Make sure you draw the eyelids. You do not see the whole iris.

Don't forget the eyebrows.

The top of the ears are at eye level.

The nose starts almost at the eyebrows and goes down just above the bottom 1/4.

The mouth is 1/2 way between the tip of the nose and the chin.

When drawing from a live model, do not start by drawing an oval for the head.

Here is an easy way that works.

1. Draw the contour of the top of the hair.

2. Draw the line where the hair meets your forehead. Draw the hair shape on the top and sides of the face.

3. Draw the shape of the jaw line from the base of one ear to the other. By the way, the jaw is not a rounded oval or you would have the mumps. Consider your chiseled chin line.

4. Draw your neck and shoulders. Your shoulders are TWO heads wide. Does the hair touch the shoulders or go behind the ears?

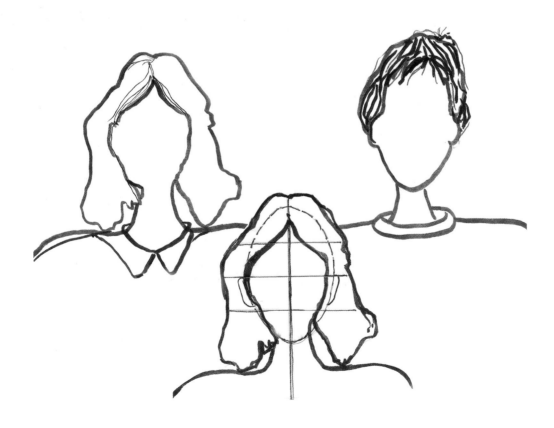

ESSENTIAL INGREDIENT 9

THE EYE RECIPE

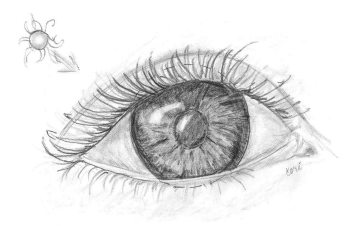

Use a #2 pencil. Use a Q-tip® to smudge or smear greys.
Start by drawing very softly with the pencil.

1. Look carefully in the mirror to notice the shape of your eye. Draw the shape and taper at both ends. Include the shape of the small tear duct.

2. Draw the narrow line you see under your eye.

3. Draw the crevice line above your eye. The crevice line is where the skin folds within the eyelid.

4. Do not draw a whole circle for the iris. You do not see the whole circle. The lids protect your eye. The iris is the colored area of the eye.

5. Inside the iris is a dark black round pupil shape.

6. Consider the light source and create some "twinkle" shapes in your eye based on where the light hits your eye. Those shapes will remain almost white. You may even use an eraser.

7. Fill in the iris with lines that radiate out from the center. You are seeing that mandala shape, like the sun with rays.

8. Draw the lines around the eye shape. Eyelashes curve in both directions above that oval shape. They are many lengths.

9. Gently, with the side of your pencil, add a layer of grey inside the "whites" (sclera) of the eye. They are not pure white.

10. Add soft grey above the eye in the crevice. Work carefully to darken every detail.

ESSENTIAL INGREDIENT 10

DRAWING WITH YOUR SCISSORS

Snip off the corners of a square to make a circle.

Snip off the corners of a rectangle to make an oval.

ESSENTIAL INGREDIENT 11

RECIPE FOR DRAWING A STILL LIFE

Everywhere We Look is a Still Life, Waiting to be Drawn

1. Do not draw the table first, *even if* your logical brain says to.

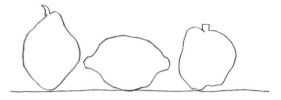

2. The object closer to you is lower on the paper. The object closest is in the **FOREGROUND**.

What's wrong with this picture?

Answer: In this illustration, the pear looks like it's floating.

If the lemon is in front, you draw it first because it is closer. The lemon is lower in your drawing and **OVERLAPPING** (in front of) the pear. You do not see the whole pear even though you know it is there. You cannot see through the lemon. You only **see** part of the pear behind and it appears a little higher even though it is on the same surface. Objects that are farther away appear higher.

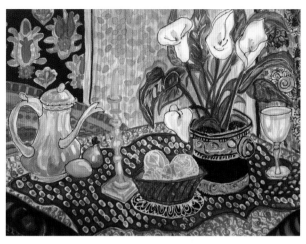

Still Life, Corinne, silk painting

In the photo below, notice the table line behind the fruit.

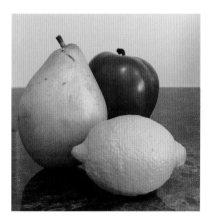

This would be a great first still life.

3. Draw what you see. It helps to have a Viewfinder to **crop** and focus on only a part of the still life so it is not so overwhelming. Cut a rectangle out of a piece of paper. You can use your viewfinder horizontally or vertically.

 Viewfinders

4. Close one eye.
 Hold the viewfinder up to the open eye. Carefully move the viewfinder away from the eye so you can ZOOM in on your still life. Focus on just what you want to draw of the still life and don't be distracted by all the other objects. Move your viewfinder left and right, back and forth, until you have an interesting picture (composition). You will not get all of the objects in your picture. Some of the objects may go off the sides of the paper. This is called "bleeding off" the page.

 Place your paper or canvas horizontally or vertically to match the direction of your viewfinder. You may also use a square.

5. Start by drawing the shape closest to you a few inches above the bottom of the paper or canvas. Leave room for your table. This will ground your objects. Look for shapes: squares, diamonds, triangles, circles and rectangles.

6. Draw the contour/outside line of the object closest to your first shape.

 With each object, ask yourself:
 Is it touching? Where is it touching? Do you see only part of the bottom of the object? Is the object behind and, therefore, just a little higher on the paper?

7. One at a time, continue drawing the shapes of all of the objects in the **FOREGROUND** (front). Drawing a still life is like a puzzle. All the pieces connect and overlap. Constantly ask yourself, for example, how many apples high is the bottle? Think about the size of one object compared to another.

8. Draw the objects you see in the **MIDDLE-GROUND**. You will only see parts of the objects behind others.

9. Next, draw the **BACK-GROUND**. Your objects may even **BLEED-OFF** and touch all sides of the paper/canvas. Draw what you see in the background.

 Note: If you place a window in the background, you will only see part of the window in relation to the other objects.

10. The last thing you will draw is the line of the table bleeding off the bottom and sides of the paper. Does the front of the table show? Do you see any of the back of the table?

 Don't get stuck in those symbols from the past. Look carefully. Leaves do not have straight lines. Flowers are not perfectly symmetrical, and they couldn't live on one single straight stem line!

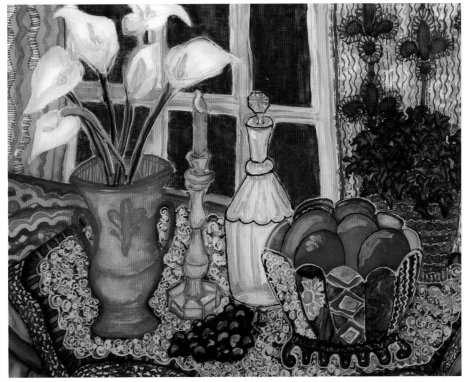

Calla Lily Still Life, Corinne, silk painting

"A picture is worth a thousand words."

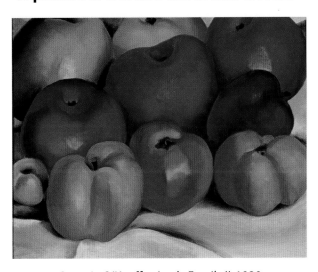

Georgia O'Keeffe, *Apple Family II*, 1920

Gift of Burnett Foundation and The Georgia O'Keeffe Foundation
© 2019 Georgia O'Keeffe Museum / Artists Rights Society (ARS), NY
© Georgia O'Keeffe Museum. Photo: Malcolm Varon 2001.
Photo Credit: Georgia O'Keeffe Museum, Santa Fe / Art Resource, NY

Look at Georgia O'Keeffe's still life, *Apple Family II*. You clearly see the bottom of the apples in the foreground. See how the ones in front are lower on the canvas. Note that only a part of the table shows.

You only see the tops of the apples that are in the back. Still, you know they are whole apples.

Draw what you see, placing one object next to and behind another.

A note about perspective:

A still life can also be painted from above, a birds-eye view.

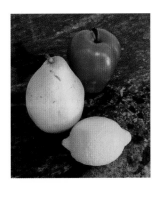

CHAPTER 5
RECIPES FOR SUCCESS

Use these symbols to easily find activities suitable for your group. Each Recipe for Success has one or more symbols above its title.

■ **Adults with Adults of Any Age**
 Baby boomers, Millennials and Young Adults

▲ **Adults, Teens and Upper Elementary**
 Age 10 and up, especially if that chapter in your life is where you lost your zest or had fear of artistic realism!

● **Lower Elementary**
 Ages 6-10

★ **Little Ones**
 Age 5

Note: Most activities can be adjusted for budding artists of all ages. All are suitable for adults.

SETTING THE STAGE

The following recipes for success will ignite your artistic capabilities while offering skills and techniques to build confidence.

Join friends, a child, or a parent and have fun exploring your artistic talents.

There are no mistakes in art.

Let us instead use the word "opportunity."

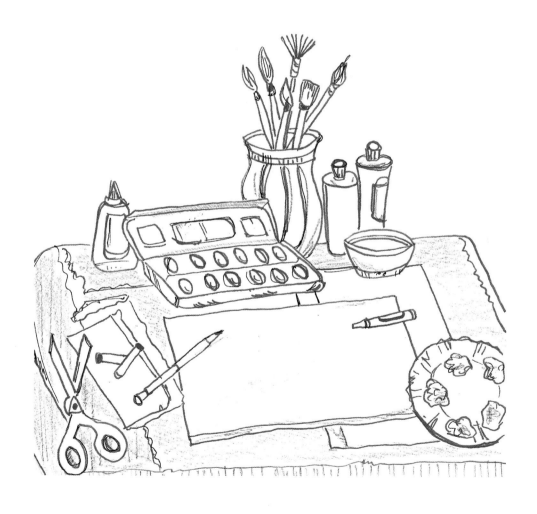

Setting the stage

- Have your work space organized with the supplies needed.
- Calm music is an option.

One of the techniques I employ in every art lesson is silence. The quiet right brain mind has no words telling it what to do. After looking at what we are going to draw, an additional technique is to close our eyes to visualize what we just looked at. Another approach is to draw the contour (outside line) of the object in the air with your pointer finger and then, using your finger, draw the outside line of the object on a blank paper or canvas. Just like in exercise, you warm up first.

Art Recipes For Success

- The lesson activities are in no particular sequence.
- Although **most** of the lessons can be adjusted for all ages, I have suggested experiences that may be more appropriate for a specific age group.
- Art materials will vary slightly depending on the age of the participants.
- Within the lesson, you will often be directed to an "Essential Ingredient" section that will give you skill and technique reminders for that activity.

You are welcome to share these activities and experiences with:

- A group of friends, men, women, couples of all ages.
- Multigenerational: parents, grandparents, young adults.
- A child or a senior. Lesson "do-alongs" are encouraged.
- Your artistic self, at your own pace.

Thank you to the children I have taught in my home. I thank all of my students from kindergarten through high school in Irvine, California for what they have taught me. I appreciate your contributions.

I'm not reinventing the wheel. These are tried and true lessons that I have used for years. My students have ownership of their feelings with success, whether it be modeling famous artists or implementing skills and techniques into their artwork and so will you!

DISCLAIMER

Standards: Much of the sample art in this book is from former students. Remember that most of these samples are based on art instruction and are samples of the completed projects. The visual that is shared is meant to be instructive and nothing like your completed piece. You will develop your own style.

ACTIVITY 1 ■ ▲

SKETCHBOOK
YOUR VISUAL JOURNAL
ONGOING OBSERVATIONAL DRAWING

Buy a hardbound sketchbook full of blank pages, approximately 8" x 11".

Record your thoughts and secret visons while gathering inspirational memories. If you hear a great quote or some inspirational words, write them down. Reflect and draw. Put it all in your sketchbook.

Observational drawing

Train your eye muscle not to just look, but to see images.

Camera, Justin, journal sketch

Ways to use your Journal

Store your verbal and visual perceptions in your bound book. Consider your sketchbook as a collection of recorded ideas and free flow creative exploration. Doodle away when your attention is occupied; it's cathartic. Your sketchbook is for you. Only share your ideas if you want to.

Don't worry if don't have your sketchbook at a magical moment. You can brainstorm later and experiment with your ideas and memories.

You can tape sketches or photos and draw about them in your book.

Use your sketchbook to practice skills. What are you interested in? Browse the *Essential Ingredients* section. What if you could draw the eye as described in that lesson? Let your fascination guide you. Do you want to make gesture drawings of a crowd or test different mediums: paint, pencil, or charcoal? You can practice in private in your own sketchbook. What if you knew more about watercolor techniques? If that interests you, ask yourself, "What is it about watercolor that I like?" Or do you want to mix colors to create new ones? Let your interests motivate you.

Paint your dreams. Draw your visions. Go out and sketch.

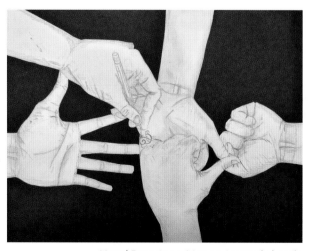

Hand Drawings, Moses, journal sketch

ACTIVITY 2

STILL LIFE
ACRYLIC OR TEMPERA PAINT

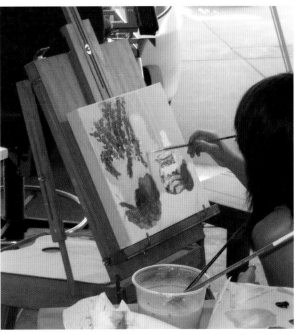

Still Life, Thanks Jessica

PREPARATION

Refer to *Essential Ingredient 11*, *Recipe for Drawing a Still Life.*

Note: Supplies and medium may differ with age level. For example, the size of the canvas, and whether you choose acrylic or tempera may vary depending on your group. This is a lesson you can do again and again.

THIS IS A MULTI-DAY, ONGOING EXPERIENCE.

Supplies for all ages:

- **Still life objects**: arrange so you have interesting viewpoints from all sides of the room. Objects may include bowls, bottles, fruit etc.
- **Mini easels** or some way to stand the canvas at an angle.

Supplies:

Adults with other adults or young adults

- canvas: 11" x 14"
- 1 piece of 11" x 14" newsprint or white paper for drawing
- viewfinder: cut small square or rectangle out of center of a paper to help you focus on the still life
- tube **acrylic** paints: primary, secondary, white, magenta and turquoise
- brushes, water, paper towels
- disposable palette or paper plate

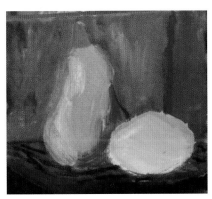

7 year old, 10" x 10"

Supplies:

Adults with children

- canvas 10" x 10"
- 1 piece of 10" x 10" newsprint or white paper
- viewfinder
- **tempera** paints: primary, secondary, white, magenta and turquoise
- brushes, water, paper plates, paper towels

Hold your canvas right in front of the portion of the still life you are going to draw. Imagine you can see right through the canvas and draw the objects the size they are.

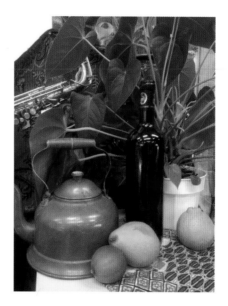

1. Set up a still life on top of a table or box that has a piece for fabric on it.

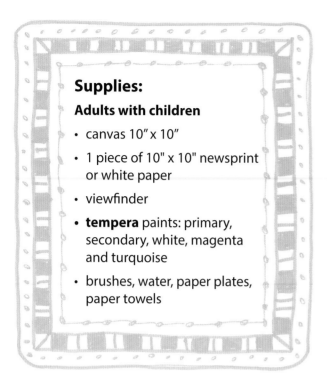

or

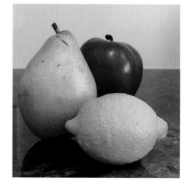

2. Decide whether your canvas is horizontal, vertical, or square.

 Use your viewfinder to "crop" (focus in on a portion) of your still life. I call this a camera.

 Hold it away from your face, close one eye and move it around and in and out until you SEE the still-life you want to draw.

3. Draw on newprint.

 With a pencil on newsprint, carefully draw the outline/contour of the object closest to you. Make the object large, even life-size. Remember your foreground (in front) objects should not touch the bottom of the paper.

Add the other objects that are next to one another in the foreground. If an object is behind, make sure it is a little higher on the paper. Draw every object one at a time.

- Note the size of one object compared to another.

- Where do they touch and overlap?

- Fill the entire paper. Be sure you have lines touching and bleeding off all sides of the paper.

4. Transfer your drawing.

 Darken the back of your newsprint paper with pencil. Hold the pencil lead on its side. Be sure to press hard, but not tear the paper. Covering it with pencil will allow you to transfer your drawing to your canvas. (This works like carbon paper. What is carbon paper? Guess you might have to look that up. Sort of like, what is black and white TV?).

5. Tape the penciled side down onto your canvas. It is the same size as your finished sketch. Press heavily and draw pencil lines over every object and all background lines. Remove the sketch paper. Go over all the transferred lines on your canvas, again with a pencil.

Note: *Do not use a permanent pen because it will later bleed through your paints.*

PREPARATION

Refer to *Essential Ingredient 2, Creating New Colors with Paint.*

You will be using either acrylics or tempera depending on your choice and age!

6. You are now ready to paint. Set up your acrylics or tempera on your palette. Remember you must create every color you use. Limit your palette. By repeating colors, you will have a unified finished piece.

7. Paint the background.

 - Paint the negative space first. The Nothing Space (negative space) is behind the still life objects.

 - Paint the table behind the objects.

Note: This is a good place to stop. Take a break. Complete your piece on another day or at another sitting.

8. Paint… Paint… Paint… until you have filled your canvas with colors that you have created.

 Let your piece dry.

PREPARATION

Refer to *Essential Ingredient 6, The Values in Shading.*

9. Think of each object. Where does the light hit the object? Show the darks and lights to create volume.

Come back later to make changes with paint. Many artists start again and again on the same canvas.

STILL LIFE CRITIQUE

Place your completed paintings on your mini easels so that your group of two or more can see them. Silently look. Absorb the colors, shapes foreground and background of each of the still life pictures in the room.

Now, have everyone complete the Reflection Zone questions. Once they are complete, decide whether you want to share your responses about your own art. If you prefer, have a member of the group comment on your painting. They, too, can discuss what works and how they might change the still life.

Be brave. Talk. Share your knowledge and feelings. This is in no way meant to be judgmental, but just a sharing time so you can try new tactics in your next still life.

REFLECTION ZONE

Tell what you like most about your still life?
What might you do differently in your next still life?
Describe the feeling you get from your still life?

ACTIVITY 3

■ ▲

CUBISM PICASSO FACE
WATERCOLOR

A no-fear of faces experience

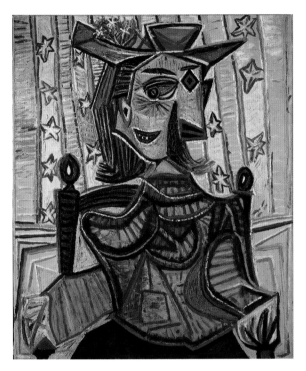

Where is she looking?

Pablo Picasso, *Dora Maar in an Armchair,* 1939, Age 58

The Mr. and Mrs. Klaus G. Perls Collection, 1998.
© 2019 Estate of Pablo Picasso / Artists Rights Society (ARS), New York
Image © The Metropolitan Museum of Art. Image source: Art Resource, NY

Picasso exemplifies an artist who reconnected himself with his child-like joy.

"Every Child is an Artist; the problem is staying as artist when you grow up."

Pablo Picasso

Modern Artist, Pablo Picasso was an artist for all times. In his 92 years, Picasso accomplished more growth through his ever-changing styles than most artists ever achieve. He did it all: painting, drawing, ceramics, printmaking and sculpture. He even created costumes for the theatre.

He was born in Spain. His father was an art teacher who helped Picasso begin drawing successfully as a young child. By his early teens he was able to paint representative renderings that looked like photographs.

At the age of 19, he went to Paris, the center of the Art World, to show a painting. He experienced artists gathering at galleries and cafes as intellects sharing ideas. He knew his goal was to return.

His first artworks from his "Blue Period" were not selling, probably because his paintings reflected the hard times he and his models were going through. He found no audience for the deep blues and suffering of his painted figures. By the age of 23, Picasso's art had begun selling, so he moved to Paris. There he met a love, one of many, and his colors changed along with his spirit. During his "Rose Period" he painted lots of Circus people using warm colors.

Picasso wanted more freedom in his art. He was tired of traditional art, having already mastered realism and developed his own styles during his Blue and Rose Periods. He became inspired by African masks with their flat forms and distorted features. Breaking objects into geometric forms and showing multiple viewpoints gave birth to a style named **CUBISM**, the beginning of Modern Art. Instead of making things look real, Picasso shocked people by painting multiple views of the same subject, thus showing many sides at once.

He created costumes and set designs, and then a series of Collages. Cut shapes, flat bright colors and patterned papers became a part of his simple, colorful paintings.

At the same time, Picasso's native country, Spain, was suffering from a civil war. Artists respond to the world around them. The small town of GUERNICA was bombed and destroyed. To show his anger at how wrong war was, he painted a huge 25-foot wide painting named after the town using blacks, whites and darker colors along with the multi-faceted angles of cubism.

Picasso advanced and influenced **MODERN ART**. His originality, productivity, versatility and imagination along with his passion for artistic growth made him one of the greatest and most respected artists of the 20th Century.

You will be creating a cubism torso (face and upper body) modeling Picasso's style. Eyes and noses will be in the "wrong places" to be viewed from multiple perspectives: moving noses, eyes and chins all around. We do have many sides to express. There is no right or wrong way to do it in your new art world, just your own creativity. Enjoy!

Take a look at how well Picasso could realistically render (draw) as a child.

Pablo Picasso, *Portrait of Artist's friend Pallares,* 1895, Age 14.
Courtesy of Museu Picasso de Barcelona
© 2019 Estate of Pablo Picasso / Artists Rights Society (ARS), New York

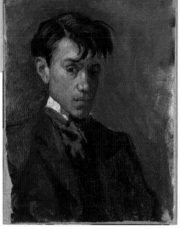

Pablo Picasso, *Self Portrait,* 1896, Age 15, Courtesy of Museu Picasso de Barcelona © 2019 Estate of Pablo Picasso / Artists Rights Society (ARS) New York

Supplies:

- 8 1/2" x 11" letter size papers
- pencil and eraser
- 11" x 14" watercolor paper
- permanent black pen (Sharpie®)
- watercolors set (I like Prang® 16 semi-moist because they have primary, secondary and tertiary colors)
- #10 watercolor brush
- water

WARM UP: 5 Minutes to loosen up!

Like stretching before exercising, do a few quick pencil sketches on white 8 1/2" x 11" letter size paper.

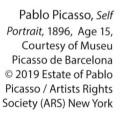

1. Make a light pencil oval in the center of the paper. Leave room at the top for a hat. Leave room below for the shoulders and neck.

2. In the center of the oval, draw a PROFILE (a side view of the face). Start from the forehead to the nose, then from the lips to the chin. Play with the features on half of the oval, making the eye, nose and other features looking in different directions. Make the other half of the face with features from varied angles. Include clothing and possibly hats from all directions. Have fun!

A cube is 3-dimensional and can be seen from many sides. Think of a diamond with its multiple facets. Even though your paper is flat, you will create an illusion of depth by letting us see many angles within the face.

PREPARATION
Refer to *Essential Ingredient 8, The Face Recipe.*

The proportion is the same even though this cubist face is **ABSTRACT** (not realistic).

YOUR CUBIST PORTRAIT

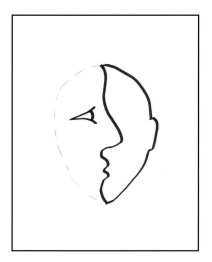

1. a) On your watercolor paper, with pencil, lightly draw the oval for your head.

 b) From the top center, lightly draw your profile line with the nose and lips facing to one side.

 c) Draw an eye so it is looking in the same direction as the nose.

 d) Draw the outside of the head line showing the ear of the face that will be looking forward.

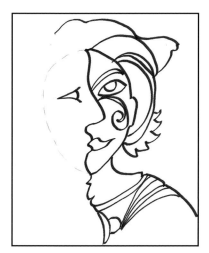

2. a) Complete the facial features on one side. Add neck, shoulders and clothing. Shoulders are two heads wide, so the shoulders will be "bleeding off" the sides.

 b) Add a hat, hair and details.

3. Now create a face on the other side. Do you see faces from both angles?

 We all have different personality traits, so have fun with this image.

4. Go over the pencil lines you want with black permanent pen.

PREPARATION

Review *Essential Ingredient 3, Watercolor Techniques.*

5. BACKGROUND

- Paint your background first.

 Watercolor is TRANSPARENT which means you can see through it. Never scrub.

- First put a drop of water in each pan of watercolor to soften the paint.

6. WATERCOLOR WASH

- Brush the negative space (the background behind the head and body) with a thin layer of just water.

- Add a color to fill the negative space.

7. WET-INTO-WET

While it is wet, add a similar/analogous color (next to it on the color wheel) to the background. Allow the colors will merge.

8. Let the background totally dry before painting the faces.

9. Carefully paint each shape in your cubism portrait.

Be careful not to put wet paint next to wet paint or the colors will run together.
Tip: You may have a tissue nearby to gently blot if this happens.

High School Watercolor Faces, Michelle Morgan, watercolor

OPTIONAL: Paint 6 different faces on one larger piece of watercolor paper.

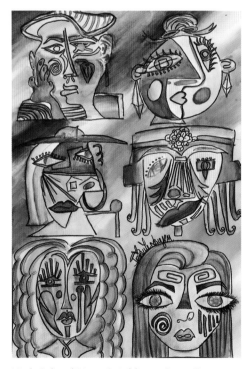

High School Piece, Brinklie, 15" x 24"

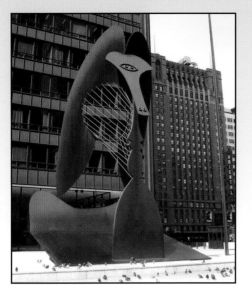

The Picasso, Daley Plaza, Chicago, IL. Pablo Picasso 1967. Photograph © Jeremy Atherton, 2006.

REFLECTION ZONE

How do you feel about the experience you had being a modern Cubist artist?
What was the best part of this lesson?
Did you know Picasso was so multi-talented? What do you know and appreciate about him now?

ACTIVITY 4

ASIAN FIGURE
COLLAGE

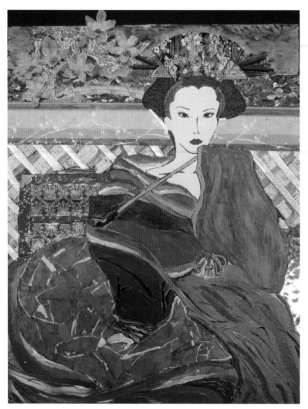

Asian Figure Collage, Brinklie, High School

Putting your knowledge all together!

The face, the body, the paint.

This calls for acrylic paint. Care must be taken as acrylic paint is permanent.

THIS IS A MULTI-DAY, ONGOING EXPERIENCE.

PREPARATION

Refer to *Essential Ingredient 7, The Body Recipe.*

Supplies:

- it would be terrific if you have a live model in a robe or kimono
- 3 pieces newsprint paper the same size as the canvas
- 16" x 20" rectangular or 20" x 20" square canvas
- pencil
- acrylic paints: primary colors, secondary colors, turquoise and white
- disposable palette or paper plates
- brushes, water, paper towels
- scissors, white glue
- assorted mixed media textured objects: fans, grass cloth, etc.
- assorted patterned and textured papers, Washi paper if possible

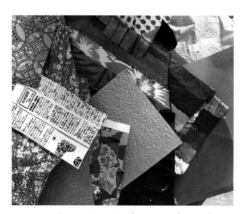

Assortment of papers for collage

1. Ask someone to model for you. Who wants to model first? Use one piece of newsprint for sketch each of 3 poses. Fast sketches, about 5 minutes each.

 You will have **OVERLAPPING** arms and legs. Observe what shapes are in front and draw those shapes first.

 You will see elongated ovals and circles. Observe proportion.

 We do not want the composition to be symmetrical, so **do not** place the figure's head in the center of the canvas.

 Have the model sit in 3 different positions.

2. Of the 3 figure drawings, choose the pose that is the most interesting to you. Use a pencil to draw eyes, nose, mouth and hair.

PREPARATION

Refer to *Essential Ingredient 8, The Face Recipe*.

3. Draw the lines of the clothing around the body.

 Lines are **ORGANIC** (lifelike).

 Fabric bends and folds to show creases.

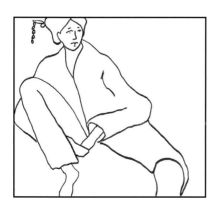

4. Create what is around the figure.

 Foreground: What is in front or lower on the canvas?

 Your figure may be on a table or chair. Draw lines to create shapes surrounding or in front of your figure.

 Middle-ground: What is next to the figure?

 Back-ground: What background is filling the space behind the figure?

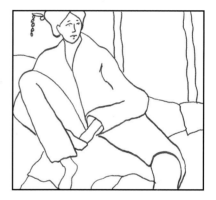

5. Transfer your drawing. Darken the back of your sketch paper with pencil. Hold the pencil tip on its side to fill the back of the page, so it is covered with lead.

 Tape the penciled side down onto your canvas. It is the same size as your finished sketch. Press heavily with pencil over every line of your figure drawing and all background lines. Remove the sketch paper. Go over all the transferred lines again on your canvas **with a pencil**.

 Note: *Do not use a permanent pen because it will later bleed through your paints.*

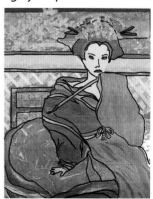

PREPARATION

Refer to *Essential Ingredient 2, Creating New Colors with Paint.*

You are now ready to paint.

Set up your acrylics on your palette. You will create every color you use. Limit your palette. By repeating colors, you will hold your piece together. Remember to continually clean your brush so the acrylic paint does not dry.

6. Start by mixing enough SKIN tone to paint the face, neck, feet, hands. To make skin color, mix Lots of WHITE, some yellow and a dot of red. Make enough skin tone as it is hard to ever make the exact color again. Paint skin color where needed (face, neck, and hands). Allow to dry before painting any facial details.

7. Paint the shapes behind your figure first. This will push your figure in front and allow you to be sure your painting is interesting before you paint your figure.

Tip: Sometimes putting down a more transparent color is a good way to start filling background shapes. This means adding more water to the acrylic paint. Remember with acrylic paints, once your paint dries, you can always change the color. Many famous artists did!

Take a break.

8. Come back, paint the clothing and facial details.

 - Add patterns, lights, and darks in the clothing and other details with paint.

 - Take time to walk away from your painting and come back to let your intuitive eye know what to add.

 - Turn it upside down to see if it feels balanced.

 - Ask a friend what they would do to make it a stronger piece.

Let the painting dry.

9. Once your entire piece is painted and dry, apply patterned and textured papers in at least 3 to 5 large areas. Cut the papers into shapes to fit into an area.

COLLAGE

The word collage comes from the French word, "coller," which means "to glue."

Add other mixed media with white glue or in the case of heavier objects, use a glue gun. Items like fan parts, ribbon, and coins will create **TEXTURE**.

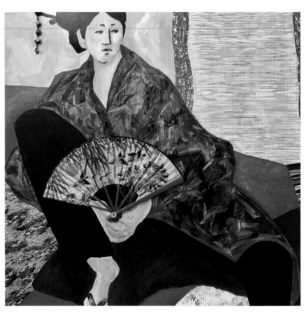

Kimono Portrait, Corinne Schaff, collage

This collage is on a square canvas. One leg is going off (bleeding off) the side of the canvas.

The head is also bleeding off the top of the canvas.

Sometimes artists do this to add interest to a painting.

What do you think?

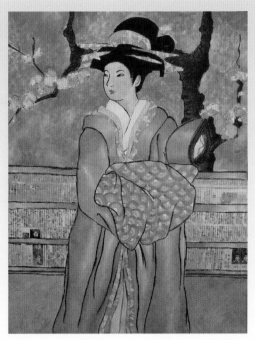

Asian Figure, Angela Lee, High School, collage,

REFLECTION ZONE

Come back to your collage at a later time to make it even more interesting.

I painted my kimono portrait and came back 15 years later to add collage materials that I collected during my travels to Japan.

How many new colors did you create with your acrylic paint?

CRITIQUE

- Share your Asian Collage Figure with your group. Silently look. Absorb the colors, shapes, foreground, and background.
- Be brave. Talk. Share your knowledge and feelings. This is in no way meant to be judgmental. It's just a sharing time.

VAN GOGH
COLLAGE

Van Gogh Self-portrait, Morgan, mosaic collage

BACKGROUND KNOWLEDGE

Talk about what you already know about Vincent Van Gogh.

How does his art make you feel?

In art school, students study an artistic style by essentially "copying" an artist's work. During the process of creating a Van Gogh collage, you will become totally involved with Van Gogh and his choices of color and the textures depicting his swirling broken brush strokes.

Crazy, passionate, depressed, manic, impulsive, emotional, post-Impressionist Vincent Van Gogh was a colorful man and artist. He only painted for 10 years from the age of 27-37, but his artwork has an impact on us today. Although he painted over 800 paintings, he only sold 1 painting during his lifetime. He became famous posthumously (after his death).

Yes, we all seem to know he cut off part of his ear. Eventually he died after a series of psychotic episodes, malnutrition, years of hard living, alcohol abuse, lack of sleep, and a sense of failure. Much of what we know about his life is through a series of letters with his brother, Theo and Dr. Gachet, who treated him during the last 2 years of his life.

Born in the Netherlands (Holland), the Dutchman with red hair worked from an early age. Vincent moved often to pursue varied careers. First he was an art dealer. Then he followed a desire to become a minister and share religion because of his humanitarian concerns for the impoverished. Lonely, he drifted through many failures and clinical depressions. With the financial support of his brother, he attended academic art schools. His paintings of peasants and the working class were dark, and Theo could not sell them in Paris. Take a moment to search: *The Potato Eaters*, 1885.

In 1886, he moved to live with Theo, who had a gallery in Paris. Heavily influenced by the excitement of artists and Impressionism at this time, Vincent's paintings changed to more colorful renderings of the Paris scenes around him. Art was his escape from life.

Seeking warmth and good health along with financial independence, in 1888, he moved to Arles in the South of France. It was there that Paul Gauguin joined him. Gauguin added stability, routine painting, lively discussion, and partying to his life. Vincent was happy and productive. He used his favorite color, yellow, to paint sunflowers. After two months, he and Gauguin fought. Gauguin was quite pompous and critical of Vincent. At this time, Gaugin fled town. Vincent later cut off his ear to give to a "woman of the night." This was a psychotic break, one in which a patient may hear things and forget what actually happened.

Hospitalized in Saint-Rémy, he painted Starry Night in 1889. He didn't sleep for three nights.

This conflicted, spirited artist was a gift to us all. He moved to Auver and from this point on he painted almost a canvas a day, producing some of his best work!

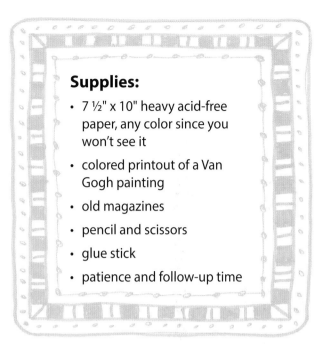

Supplies:

- 7 ½" x 10" heavy acid-free paper, any color since you won't see it
- colored printout of a Van Gogh painting
- old magazines
- pencil and scissors
- glue stick
- patience and follow-up time

2. Look at the colors you will need and pull or cut some pages from the magazines that have colors and textures appropriate for your piece.

- Cut small dashes, mini rectangles, like the broken brushstrokes and movement of Van Gogh's paint.
- Begin in the center. Coat a small area at a time with glue from a glue stick.
- Fill the shapes with cut pieces of magazine colors that match Van Gogh's painting.

1. Once you have selected the Van Gogh painting you are going to study, place your acid-free paper either horizontally or vertically as needed.

 Draw the main lines you see. If you are overwhelmed, turn your picture upside down. Look at the lines and shapes.

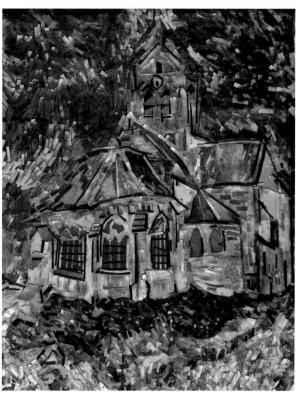

Van Gogh's Church at Auvers, Corinne, collage

While doing the above piece, I felt connected to his passion.

Option: Do another Van Gogh piece using oil pastels.

Mix the oil pastels to get the exact colors. Use the oil pastels on grey construction paper so you are sure to use opaque rich colors. This also becomes a color mixing experience.

REFLECTION ZONE

Are you proud of your artwork? Why?
Have you learned anything new about Vincent Van Gogh?
Knowing that Vincent Van Gogh probably had a mental illness, if he were alive today and on medication, do you think his artwork would be different? There are many theories, movies and book written about his life, illness, and behavior.

ACTIVITY 6

HEARTS
ACRYLIC OR TEMPERA PAINT

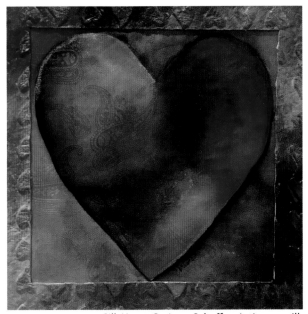

Silk Heart, Corinne Schaff, painting on silk

This experience works for all ages:

- adults with other adults
- grandparents with children
- you alone
- children with children

Use a limited color palette. Artists of any age may do four smaller distinct heart pictures on the same paper.

In the late 50s and 60s, **POP ART** was the next movement that followed abstract expressionism.

During a healthy American economy and the Mad Men boom of advertising, consumer products driven by billboards, ads, and branding in supermarkets were depicted in art exemplified by Andy Warhol's Campbell's soup cans.

Crazy fun stuff was happening with the joy of the 60s. The artists of the time, Oldenburg, Rauschenberg, Warhol, et. al., along with Jim Dine, made ordinary everyday objects remarkable. Additionally, the "Happenings" was a form of performance art which involved the viewer as a part of 3-dimensional sculptural art.

> **On the internet, take a look at:**
> *Blue Clamp*, 1981, Jim Dine, Age 46
> *Abyss of Good Soldier*, 2010 Jim Dine, Age 75
>
> Both can be seen at Museum of Modern Art in San Francisco, California.

Jim Dine was born in 1935. Full of LOVE, he is at the time of this writing, in his young 80s.

Considered a POP artist, he is so much more: a painter, poet, sculptor, and performance artist.

As a child in the 1940s, Dine was considered to have a "learning disability." *This was at a time when traditional left-brain learning was the only educational approach.* He states, "I just couldn't concentrate. So, I was able to get through school by drawing." (*Scholastic Art* 2008). Most importantly, he was **Art-Smart**.

After graduating from Ohio State, Jim Dine moved to New York. Aside from Pop art paintings, he created Assemblages with actual objects glued to his canvas. You can do the same.

Through his art, Jim Dine expressed feelings along with personal passions. His Hearts were visual symbols representing the love for his wife and so much more.

He truly gave his Heart to Art.

Now it is time for you to "paint your heart out!"

1. Fold your 12" square paper in half. Draw ½ of the heart with the middle of the heart on the folded side. Do not worry if it isn't exact. When you paint the piece, it won't have a perfect edge!

2. Cut the heart out and trace around it with a pencil onto your canvas. If need be, you can tape it down to hold it in place.

1. 2. 12" x 12" canvas

Note: The heart is SYMMETRICAL which means if you draw a line down the middle it is the same on both sides.

Take a break. Look on the internet to find images of Jim Dine hearts.

OPTION: You may decide to put 4 hearts on one Canvas. This means your template will be 4" x 4". You will create 4 different paintings within one canvas.

12" x 12" canvas

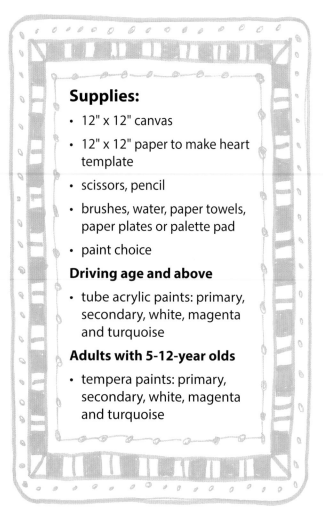

Supplies:

- 12" x 12" canvas
- 12" x 12" paper to make heart template
- scissors, pencil
- brushes, water, paper towels, paper plates or palette pad
- paint choice

Driving age and above

- tube acrylic paints: primary, secondary, white, magenta and turquoise

Adults with 5-12-year olds

- tempera paints: primary, secondary, white, magenta and turquoise

PREPARATION

Refer to *Essential Ingredient 2, Creating New Colors with Paint.*

LIMIT YOUR PALETTE. Only place the colors you will be using on your plate or palette.

3. **Paint your background or negative space first.** It is fun to look at the image this way. The heart is positively there, but the negative space behind becomes very important.

4. After you have painted your negative space behind your heart, let the canvas dry.

If you have 4 hearts on your square canvas, paint 4 separate and different backgrounds, one behind each heart. Allow the background to dry before painting the hearts.

5. Paint your heart. You will be able to get a fairly controlled outside heart line. That way you won't lose the heart to the negative space.

Art is a process

Heart One and the same canvas an hour later. Ever changing. What will be next?

Heart One and Heart Two, Ian Schaff, acrylic

REFLECTION ZONE

Since there may be younger artists in the group, you can share these ideas out loud or write down their responses.

What did you learn about the artist Jim Dine?
How would you tell someone what pop art is?
Was it fun to paint this canvas? Did this painting make you feel joyful?

PLEIN AIR LANDSCAPE
ACRYLIC PAINT

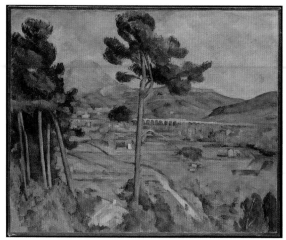

Paul Cèzanne, *Mont Sainte-Victoire and the Viaduct of the Arc River Valley*, 1882-5
H. O. Havemeyer Collection, Bequest of Mrs. H. O. Havemeyer, 1929. Courtesy of Metropolitan Museum of Art, N.Y.

Supplies:

- pencil (don't use permanent pen)
- 11" x 14" or 12" x 16" canvas
- acrylic paint: primary and secondary colors, plus turquoise and magenta
- tabletop easel if you are inside or portable easel for outside.
- black and white paint
- disposable palette or paper plate
- sturdy acrylic brushes, water, paper towels
- if you cannot paint outside, find a photograph of a beautiful place
- viewfinder

In French *en plein air* means "in open air." Many artists find being on location is the best way to capture natural light.

In early 19th century America, the Hudson River School painters (NY) were painting outside before 1840, the year oil paint first came in tubes. Can you imagine mixing color pigments with oil if it was windy?

A bit later in France, artist Claude Monet even went out on a boat to paint. His goal was to capture the right light at different times of day using visible brush strokes. The Impressionist movement was named after one of Monet's paintings: *Impression Sunrise*, 1872. This style was a major change from the academic rules of art.

Following Impressionism came Post-Impressionism: 1886-1905. Younger artists like Van Gogh, Gauguin, Seurat and Cèzanne reacted by shifting the role of art. They went beyond representation to involve emotions, symbolic undertones and a focus on subject.

Cèzanne painted in the South of France.

In Aix-en-Provence, he did multiple paintings of the same mountain, Sainte-Victoire, which you see on this page. Splitting planes of color with small brush strokes, his style was more structured and geometric. The influence of the post-impressionists was the beginning of modern art and the birth of Cubism, Fauvism, and Expressionism.

Meanwhile in the early 1900s before the great depression, The California Plein-Air School emphasized the loose, painterly rendering of nature with impressions of land and seascapes throughout California.

Photographic film was not available until Kodak came on the scene in 1885. Back then, artists working on landscape paintings often started by making quick color sketches or mini paintings outside. They then took their sketches back to the studio, indoors, where they used them to complete a large canvas. (Example: George Seurat's "Sunday Afternoon on the Island of La Grande Jatte") … So if need be, you, too, may work from a photo for this landscape painting experience.

Note: This calls for acrylic paint. Acrylic paint is permanent once it dries.

Younger artists may enjoy painting with Q-tips® and tempera as suggested in the Alternative Activity at the end of this lesson.

Background Knowledge

On the Internet, search:

- Paul Cèzanne landscape images
- *Plein air* images

1. Place your canvas horizontally or vertically depending on your landscape.

 Close one eye. Hold the viewfinder up to the open eye.

 Carefully move it away from the eye so you can ZOOM in on the landscape or seascape you want to place on your canvas.

2. **Foreground:** Lightly with pencil, draw the outside contour line of the objects closest to you. Objects closer are larger and lower on the canvas. The arrow indicates horizon line.

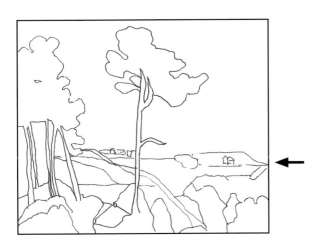

For example, look at the Cèzanne painting on the previous page. If you were drawing that landscape, you would first draw the trees in the foreground along with the outline of the vegetation, followed by the plots of land, bushes, and then the smaller trees farther away.

3. **Middle ground:** Draw what is in the middle part of your landscape.

 Background: Finally draw what lines meet the sky. In the Cèzanne painting, there are foothills in front of the mountains.

 Where is the horizon? The horizon line is where the earth and the sky meet. You don't actually see a **line**, but the arrow indicates where the horizon probably is.

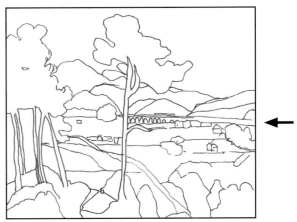

PREPARATION

Refer to *Essential Ingredient 2, Creating New Colors with Paint.*

Remember to create your colors. Don't use a color right out of the tube.

4. Start by painting the sky. It is not one smooth color. Try mixing colors right on the canvas by placing one brush stroke of color next to a new color. You can almost feel the strokes. If you are outside, you will have to work quickly so the acrylic paint doesn't dry.

Tip: Be sure to keep cleaning the paint brushes so the acrylic paint doesn't harden on them.

5. Paint any areas of water and any reflections you see.

6. Paint the background. Colors may be softer, lighter in the background and middle-ground depending on the light source. One of the advantages of painting outside is to capture the lights, darks and shadows as you see them.

7. Paint your foreground. The colors may be more intense.

Your paint doesn't have to be smooth.

Think: TEXTURE, TEXTURE, TEXTURE. Let your brushstrokes show. The objects in the foreground have more detail. You can almost feel the textures.

How many greens can you make?

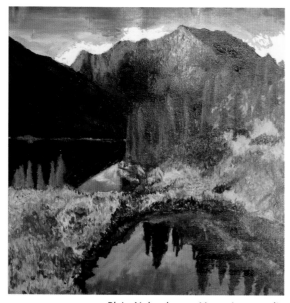

Plein Air landscape, Moses Lee, acrylic

Alternative Activity:
Mini Horizontal Landscape
Appropriate for upper elementary

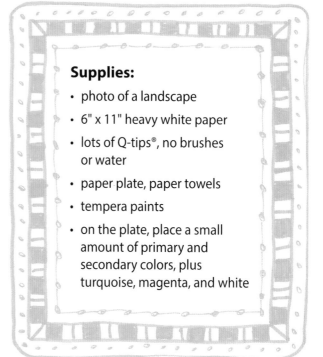

Supplies:

- photo of a landscape
- 6" x 11" heavy white paper
- lots of Q-tips®, no brushes or water
- paper plate, paper towels
- tempera paints
- on the plate, place a small amount of primary and secondary colors, plus turquoise, magenta, and white

1. Follow the first three steps in the *Plein Air* Landscape activity.

2. Mix small amount of the color on the plate or canvas. Paint with the Q-tip®. Allow your textures to show.

 Each time you need to make a new color, use a new Q-tip®.

Have you ever seen someone painting outside?

This piece is by an artist friend who has painted *en plein air* all over the world. Thank you, Linda Wissler.

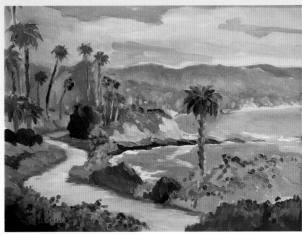

Laguna Beach, Linda Wissler, oil
Wisslerpleinairart.com

Portable easel box suitable for plein air painting

REFLECTION ZONE

Painting a landscape is a major accomplishment. How do you feel?

What will you do differently next time?

Were you able to place color on your canvas without making it totally smooth? Did it have a texture? Could you feel the paint?

ACTIVITY 8

MONOCHROMATIC CITYSCAPE 2-POINT PERSPECTIVE
MARKER DRAWING

Be an architect (an artist who designs buildings).

PREPARATION

Keep a bookmark at Essential Ingredient 5, Gaining Perspective as this activity relies on definitions and skills introduced there.

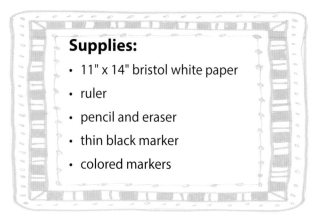

Supplies:
- 11" x 14" bristol white paper
- ruler
- pencil and eraser
- thin black marker
- colored markers

Architects draw a lot of straight lines. So have your ruler ready.

Note: All pencil lines should be very light.

1. Place your horizon line in the middle of your 11" x 14" paper.

 You will need to measure on both sides so that the horizon line is parallel to the top and bottom of the paper:

11" x 14" paper

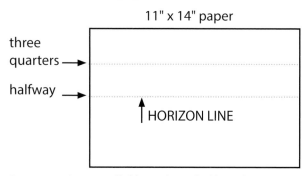

three quarters →

halfway →

↑ HORIZON LINE

Draw another parallel line about halfway between the horizon line and the top of your paper.

Vanishing Points

2. Place a small vanishing point dot on both sides of the horizon line.

First Perpendicular Line

3. Start by drawing a 3" line perpendicular to the horizon line.

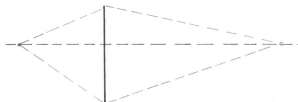

Converging Lines

4. Draw lines from both vanishing points to the top and bottom of the first perpendicular line. These are called converging lines.

The Sides of Your First Building

5. Draw two more perpendicular lines between your converging lines. (Put one on either side of the first perpendicular line.) These will be the sides of a building.

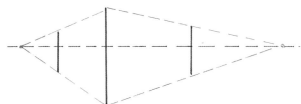

Second Building

6. City drawings have at least one other building. Repeat the above steps 3 – 5 to make another building behind the first and touching it.

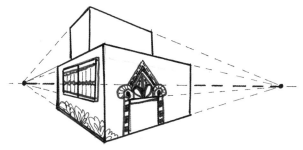

Place windows, doors, and architectural details into each building. What if you lived or worked in the building? What would you want?

If you want, draw a third building following the same steps. You may continue drawing buildings, one at a time until you have built a city.

Because you are an architect and artist, have fun creating varied tops and details to the buildings. This will make a more interesting skyline.

Now, like Magic ...

7. Erase your horizon and converging lines.

No architect's drawings show all the lines you have drawn. You know why? Because after they use them to make the building shapes they want, **they erase them**.

Make it MONOCHROMATIC

8. Mono means one. Chrome means color.

See how many markers you have that are variations of one color, say blue, as in the cityscape below. Color in your buildings with markers using only one color.

Hint: Black and white and grey are not colors, so use them as much as you want!

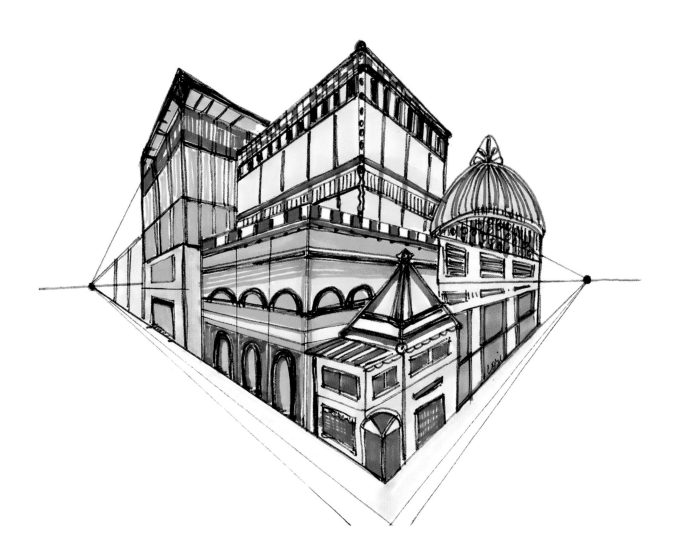

BAG OF JUNK
DRAWING

Supplies:

- Paper lunch bag filled with 6 objects: Go to the garage or "junk drawer." Secretly put 6 objects in a brown paper lunch bag. Objects cannot be harmful.

- Varied hardware pieces like hooks and bolts are good.

- You will be giving the closed bag to someone else. That way they will not be able to see the objects when they first draw.

- 8 ½" x 11" letter size paper for warm-up

- Thin black felt tip markers

- 11" x11" white bristol board paper

Warm up (10 minutes)

1. Draw on the 8 1/2" x 11" paper with black marker. Without talking or looking in the bag, **feel** and draw the outside line (contour) of one object.

2. Draw any inside lines of that object based on feel.

3. Repeat until you have drawn all 6 objects by feel. Leave the objects in the bag.

Activity:

Draw on the 11" x 11" paper using a thin black felt tip marker.

1. Take one object out of the bag and carefully draw what you **see**. You will first draw the **CONTOUR** line and then all of the inside lines that you see on that object. The objects should all be at least life size or larger than life!

2. Take out another object. Draw it **in back** of the first object. Try to place the object so it touches one side of the square paper.

 Remember, when an object **OVERLAPS**, you do not see all of the object that is in back

3. Take out a 3rd object. Draw it **touching another side of the square** paper.

4. Make the 4th object partially **BLEED-OFF** (go off) the side. Continue drawing all the objects at least once until you have filled the paper. Objects will touch and overlap.

To complete your composition, you may need to repeat the objects to fill your square. Let your eye judge when it is done.

- The size of these objects may grow or become smaller.

- Objects may be drawn from varied viewpoints (e.g., the top or sides).

- Objects must touch one another or **overlap** (one behind another).

- Objects must touch the sides of the square paper or **bleed off** all 4 sides of the square.

Make thick and thin lines with black markers. Blacken in **SHAPES** to complete your composition.

Rotate your square and decide which is the top or bottom of your piece. Notice you have a "birds eye" view.

REFLECTION ZONE

Touch is an important sense. What was your experience drawing from touch? Do you believe how well you can draw something without looking at it?
What would this look like if you enlarged it to the size of a 36" x 36" canvas painting?

OPTIONAL ACTIVITY

Consider doing a large painting with objects that tell something about you. Paint it with black and multiple shades of grey paint. THIS MAY BE THE ABSTRACT YOU.

ARCHITECTURAL DOOR
DRAWING

Take photos of wonderful doors you see during your travels. Search "architectural doors" online. Look in magazines to find doors that fascinate you.

In this activity, you will draw an architectural door FREEHAND, without using a ruler.

Can you see that this door is really made up of simple geometric shapes, decorated with patterns?

The secret to drawing something complex is to visually break it down into parts, and then draw one shape at a time. That's what we'll do.

The Interior Shapes

1. With a pencil—softly draw the rectangular shapes that you see: the windows and interior panels.

 Align your drawing with the top and sides of your paper.

Supplies:

* photo of an elaborate door
* white 11" x 14" bristol paper
* pencil
* thin black felt tip marker
* willow charcoal, optional
* NO RULER

The Frame

2. Draw the outside contour of the frame around the door, like you are framing a picture.

 All doors have a frame.

Adding Decorative Patterns

3. With your pencil, if there is something in front or next to your door, draw it.

4. Draw all larger shapes inside the frame. Think simple geometric shapes.

 Your door is probably symmetrical, meaning it has the same designs on each side.

 Draw every single pattern and all detail lines surrounding the door.

 Feel free to add details from another photo or your imagination.

5. Go over all of your lines with the thin black felt tip pen.

 Erase any pencil lines that still show.

 Note the fun quality of the irregular lines you drew *without* a ruler.

Finishing Your Door

PREPARATION

Refer to *Essential Ingredient 6, The Values in Shading*.

6. Finish your piece with a soft layer of willow charcoal or a pencil on its side to create shadows.

 OR

 Use the stipple technique to show values of dark and light.

Window, Angela Lee, stipple technique

Entry Door, Brian Pak, H.S., pen and ink with charcoal

Alternative Activity:

Take a photo of your home, and draw it.

221 Essex, Corinne, pen and ink

If you look, you can find all kinds of interesting doors, maybe in your own neighborhood.

Room With a View, Corinne, silk painting

REFLECTION ZONE

How did it feel drawing freehand? Did you want a ruler or straight edge?

Aside from drawing the door, did you add anything from another photo or your imagination?

MUSICAL INSTRUMENTS
TEMPERA PAINT

George Braque, *Vase, Palette, and Mandolin*, 1936 Collection of SFMOMA. Purchase with the aid of funds from W. W. Crocker © Artists Rights Society (ARS), New York / ADAGP, Paris; photo: Ian Reeves

Supplies:

- musical instruments or photos
- 12" x 12" colored construction paper
- permanent fat black marker
- a color wheel with 12 colors, found in *Essential Ingredient 1*
- tempera paint: your favorite color plus, your chosen color's complimentary color
- white paint
- palette
- paper towels and water
- #8 or #10 round camel brush

Cubism

George Braque and Pablo Picasso were the "inventors" of CUBISM, which has been considered the most influential art movement of the 20th century.

Born in 1882, Braque spent his childhood in Le Havre, France, and planned to become a house painter, just like his father and grandfather.

In his late teens, Braque took night courses in painting at the local École des Beaux-Arts. That's when his interest in art took off.

Cubism is a non-realistic style. Without perspective to give a 3-D look to 2-Dimensional objects, the forms in Braque's still-life "have no choice" but to appear flat.

By leaving realism behind, Braque was able to express what was important to him about the objects. In this piece, it almost feels as if the objects are falling. Doesn't it feel as if you could reach out and touch them. I almost want to catch them!

Why did he do this? Braque described this approach as "a technique for getting closer to the object." He said, "For me that expressed the desire I have always had to touch a thing, not just look at it."

In the upper left of the painting is an image that seems musical. Is it a musical instrument? If so, he invented it.

If you like, you too can invent your own musical instruments in this Activity.

Background Knowledge

On the internet search:

- Braque musical instruments
- Picasso musical instruments
- CUBISM

Drawing Cubist Musical Instruments

1. Using permanent pen, carefully observe and draw an instrument or part of an instrument from a photo or actual instrument. Draw it so it touches and BLEEDS-OFF (goes off) one side of your paper.

2. Draw a second instrument or part of one on the other side of your paper so that it too is touching or bleeding off the side of the paper.

 Instruments can be larger or smaller to create interesting shapes.

3. Draw more instruments, one behind another and OVERLAPPING.

 Fill the paper with instruments or parts of instruments that go off all sides of your square.

Note: What if you make a "mistake?" … a.k.a. a creative opportunity?

Change your instrument and paint over any lines you don't want.

OR

Like the Cubist painters, maybe you want to invent some non-realistic instruments.

This piece is not yet complete since objects have to touch, overlap and bleed off all sides of the paper.

A NOTE ABOUT POSITIVE AND NEGATIVE SPACE.

In this project, the instruments are positively there!

The negative space is the "nothing-space," the air behind them.

PREPARATION

Refer to *Essential Ingredient 1, Our Colorful World: Basic Color Theory*, and *Essential Ingredient 2, Creating New Colors with Paint*.

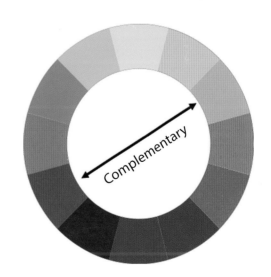

4. Choose and create your paint colors.

 Choose from the following complimentary color pairs:

 - red and green
 - yellow and purple

 Or

 - orange and blue

 You will be painting using a favorite color plus the complimentary color that is across from it on the color wheel.

 Along with these two colors, you get to use the colors immediately next to them on the color wheel.

Example: If you chose red and green, this means you get to use all of the reds and all of the greens that you can create.

- Besides basic red, there is purple-red and orange-red. Remember, you can change those reds by adding a little or a lot of white.
- Besides basic green, there is blue-green or a yellow-green.

And yes, white added to any green is "legal."

Create your reds. Create multiple greens.

Blue and Orange Instruments, 5th grade

5. Paint one shape at a time.
6. Once all the paint is dry, go over every black line of your drawing with permanent black pen. This will "pop" the details of your original drawing.

 Because of this exciting color combination, your artwork will have the vibrancy and pizazz to come alive. You can almost hear the music it makes!

REFLECTION ZONE

What is the title of your piece?

Did you carefully draw realistic musical instruments, or did you invent like the Cubist painters?

With your group, place your pieces together like a puzzle or a quilt. Tell each other what you enjoyed about this experience.

FAUVISM LANDSCAPE
ACRYLIC, TEMPERA, OR OIL PASTELS

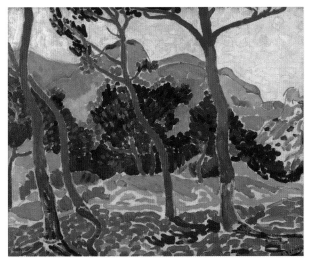

Andre Derain, *Les Arbres (The Trees),* 1906
Courtesy of Albert-Knox Gallery, Buffalo NY.
Gift of Seymour H. Knox, Jr. in memory of Helen Northrop Knox.
Photo credit: Albert-Knox Gallery/Art Resource, NY
© 2019 Artists Rights Society (ARS), New York / ADAGP, Paris

Supplies:

- inspirational color copy of Fauve artwork by Derain or Matisse
- 11" x 14" canvas or 18" x 18" construction paper
- paint choices: you may use either acrylic on canvas or tempera on construction paper
- tabletop easel, for canvas only
- primary and secondary colors, plus turquoise and magenta
- black and white paint for gray "start lines"
- brushes, water, paper towels
- disposable palette or paper plate
- Q-tips®

Fauvism

The Fauvism style brought about the use of intense color and visible brush strokes. The Fauvism art movement lasted just five years, from 1905 to 1910, but was of central importance to the emergence of Expressionism.

Working together in the south of France, Fauve artists Henri Matisse and André Derain, among others, savored the emotion of pure color over realism. Their wild brushstrokes related to reality but were abstracted, as you can see in Derain's painting.

Warm colors moved forward on the canvas. Cool colors receded. Paints were applied in a painterly fashion, one piece of paint next to another. Brush strokes were visible with the emphasis on movement and energy.

The most powerful art critics then (or possibly ever), were members of the *Société des Artistes Français.* The group was nicknamed "the Salon" because they chose which artists' work would appear in the Paris Salon, the greatest annual art show in the world.

Fauvism was completely rejected by the Salon, which is at least partly why the movement was so short-lived. They called these new artists the Fauves, which translates in French to *Wild Beasts.*

Let's be inspired by Matisse and Derain as you create a FAUVE landscape. Follow in their footsteps. Break out from the traditions of realism. Let's get wild.

THE ACTIVITY IS A MULTI-DAY, ONGOING ACTIVITY.

Background Knowledge

On the internet Search:

- Fauvism
- Henri Matisse images
- André Derain images

1. On a computer, find, select and print a color copy of a Fauve landscape.

 You will replicate and study the style, colors, and textured brushstrokes.

 Here are some strong examples of Fauve land and seascapes.

 Matisse:
 - "The Roofs of Colliouré," 1905
 - "Promenade among the Olive Trees," 1905-6

 Derain:
 - "Mountains of Colliouré," 1905
 - "Arbres à Colliouré," 1905
 - "Charing Cross Bridge," 1906

2. Place your canvas on a table easel with your color copy.

3. Mix a grey by using white and a dot of black.

4. Make your "start lines."

 Using the grey you mixed, with a brush or Q-tip®, create the horizontal organic, lifelike lines for any landscape areas in the foreground.

Remember objects that are closer to you are placed lower on the page.

With your grey, draw the objects in the middle ground, above the objects in the foreground.

Add any trees. Do they touch the bottom or the top of the canvas or paper?

What is in the background?

You will be covering over your grey lines, so don't be a perfectionist. Using "start lines" is a fast way to break up and plan your space before adding color.

5. Step back and look at your piece. Do you see a horizon line? If not, can you tell where it is?
 - In a landscape, the horizon line is where the earth and sky meet.
 - In a seascape, the horizon line is where the water and sky meet.

PREPARATION

Refer to *Essential Ingredient 2, Creating New Colors with Paint*.

Painting Your Fauve Landscape

6. Start by painting the sky at the top of your piece. Paint what is in the background. **You are a wild beast**. Mix colors to match those in the artist's work. See how close you can get to the recreating the same color as the master Fauve artist.

7. Paint what is in front, the foreground. You are applying "pieces" of paint with either a brush or Q-tip®.

8. Paint all of the objects in the middle ground. Show your brush strokes.

9. This is a good time to WALK AWAY, and take a break from your work.

10. Come back to your piece. Ask yourself, "What does the painting need?" Relax and open to the feelings and ideas that come to you.

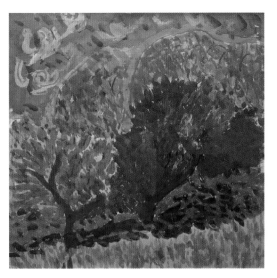

Fauve Landscape, Clark Miller, 4th grade, tempera

Alternative Activity: Oil Pastel Fauve Landscape

Supplies:
- inspirational color copy of Fauve artwork by Derain or Matisse
- oil pastels
- 12" x 18" colored piece of construction paper

Oil pastels like oil paint, mix beautifully together to create the effect of an oil painting.

Using oil pastels, follow steps 1 through 13.

Fauve Seascape, Michelle, H.S., oil pastel

11. Continue painting. Don't blend the colors into one solid smooth area. Let the colors unite right on the canvas or paper.

12. Let your painting dry.

13. Once the piece is dry, check if your canvass if totally covered with paint. If not, use more colors for any detail lines and designs that will complete your painting.

REFLECTION ZONE

Were you able to mix the colors that your Fauve artist used? What worked for you? What did you learn?
Did you feel your "Wild Beast" come out while using expressive colors and textured brushstrokes?
What was most joyful for you in creating from your wild side? Remember: There is definitely no right or wrong with the Fauve painters.

EXPRESSIONIST SELF PORTRAIT
ACRYLIC OR TEMPERA PAINT

Alexej Von Jawlensky, *Child with Doll,* 1910
The Blue Four Galka Scheyer Collection.
© Norton Simon Museum

Alexej Von Jawlensky was a Russian expressionist painter active in Germany. **Expressionists** wanted their art to portray internal emotions rather than external reality. Here, in "Child with Doll" you can see the artist wasn't interested in making a realistic portrait. He uses strong colors and flat shapes to evoke the emotional experience of his subject.

Born in 1864, Jawlensky began his art studies after a short career as an officer in the Russian army. At age 30, thanks to a rich sponsor, he moved to Munich, Germany. There, he became a key figure in the Expressionist movement.

Together with artists such as Franz Marc and fellow Russian, Wassily Kandinsky, he formed *"Der Blaue Reiter"* (AKA "the Blue Riders"). The Blue Riders believed color carried spiritual meaning. Blue was considered the most symbolic color. "Rider" stood for their goal of moving from realism to expressing emotion in their art.

Expressionism soon ran into strong criticism from the German art establishment. The government labeled it "un-German," and passed a resolution against "degeneracy in art."

Jawlensky fled to Switzerland as World War I began. There, he continued to work on his art. He wanted his portraits to clearly reveal a person's real nature, their soul.

In between the two world wars, Germany became a center of modern art, and Jawlensky returned. As the Nazis came to power, though, Expressionists rebelled, protesting through their art. In 1937, the Nazis banned all Modern Art. The Nazis burned books and confiscated art. They confiscated Jawlensky's paintings.

Under intense pressure and suffering from arthritis, in 1937 Jawlensky stopped painting. He was 73.

Our world impacts Art.
Art has a huge impact on the world.

Supplies:
- a hand-held mirror
- black crayon (do not use permanent black marker)
- canvas (12" x 12" square or 11" x14") Your piece may be a square or a rectangle placed vertically.
- brushes, water, paper towels, paper plate or palette pad
- Q-tips® or thin brush
- paint (see Acrylic vs. Tempera Paint)

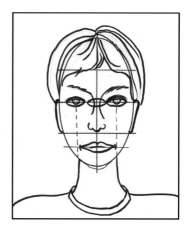

Supplies: Acrylic vs. Tempera Paint

Adults with other adults or young adults

• tube acrylic paints: primary, secondary, white, magenta and turquoise

Adults with 5 to 12-year-olds

• tempera paints: primary, secondary, white, magenta and turquoise

Making an Expressionist Self Portrait

PREPARATION
Refer to *Essential Ingredient 8, The Face Recipe.*

1. Prep your canvas.

 Start with a white canvas. Prep it by applying a coat of grey or light brown paint.

 Use thick enough paint to make the canvas **OPAQUE** (not see-through).

 Let it dry.

Following *The Face Recipe*

2. In the middle of the canvas, with a light touch of the crayon, gently create an oval for the face.

 Use black crayon because it doesn't have an eraser and the lines are thicker than a pencil. Do not press too hard with the crayon.

3. Make horizontal and vertical guide lines on the oval, per *The Face Recipe*.

LOOKING AT YOURSELF IN THE MIRROR

4. Indicate the shapes for the eyes, nose, mouth, and eyebrows.

 If you see them, add the ears, according to *The Face Recipe.*

5. Make your neck.

 If you see parts of your shoulders, make the shoulders go off both side of your canvas. Remember those shoulders are two heads wide.

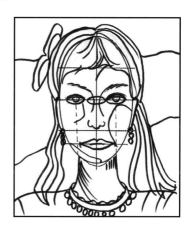

6. Add cothing details.

 Continue using very soft lines to create the visible details of your clothing.

 All of your soft crayon lines will be painted over. So, if you don't like a line, you will cover it—just like the famous artists do.

7. Create a background.

 Draw a few organic lines (life-like, not geometric) in the background to divide the space. Lines should touch and bleed off the edges of the paper.

8. Give your face character.

 Use very soft crayon lines where you see shadows or darks and lights in your face and neck.

GO WILD AND PAINT!

Express yourself!

- Stay away from black paint for now.
- Try creating new colors right on the canvas like Jawlensky did.

PREPARATION

Refer to *Essential Ingredient 1, Our Colorful World: Basic Color Theory.*

and

Refer to *Essential Ingredient 2, Creating New Colors with Paint.*

EXPRESSIONISTS used their intuition to decide and place bright colors and **large flat** shapes directly on the canvas.

What colors feel right to you?

Enjoy the experience, free from traditional, realistic art.

9. Fill the background shapes first (behind your face).

 Use only colors that you create. No colors should be directly out of the bottle or tube.

 Example: You can change the blue by adding a dot of white or green so it's not right out of the bottle or tube.

- Think about maybe darker more intense colors in the background and lighter, warm colors for the face.
- To make a color lighter you add white (tint).

TEXTURE is the way something feels.

10. You may add texture to your background.

 See what Jawlensky did in his self portrait.

11. Make color for the skin tone.

 Make a light or dark brown with the 3 primary colors. For a light skin tone, use a lot of white with some yellow and a dot of red.

12. Fill your face with varied colors.

 Have fun defining your nose by placing a lively color on one side.

13. Let your painting dry.

 Remember: Between colors, clean and dry your brush. Store the brush, bristle up and pointed.

14. Now paint the eyes and mouth.

15. Paint your clothing.

 Your colors do not have to be smooth and perfect.

16. Paint your hair.

 Note: It is not just one color. Go wild as would any Expressionist painter!

 Q: If your hair is brown, what is the recipe for brown?

 A: Mix the 3 primary colors together: red, yellow, and blue.

17. Add important black lines.

 With a small brush or Q-tip®, add important black lines. This probably means painting the crayon lines you started with.

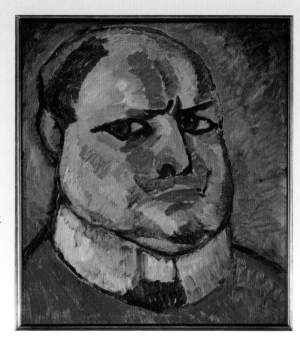

Alexej Jawlensky, *Self Portrait,* 1912,
Courtesy of Staedtisches Museum
Photo Credit: Erich Lessing/Art Resource, NY
© 2019 Artists Rights Society (ARS), New York

REFLECTION ZONE

How did you feel using non-traditional colors for the face?
What did Expressionist painters want to show in their art?
Describe the best part of your Self-portrait. What do you like most?

SAILBOATS
WATERCOLOR, TEMPERA, OR ACRYLIC PAINT

Sailboat, Miranda Burgett

Joyful Sails, Emily Kubisty

Calm Wind, Corinne

Supplies:
- a visit to look at & draw sailing boats. *OR*
- search photos of sailboats & print your favorite.

THE PAINT OF YOUR CHOICE:

- **With Watercolor:** 11" x 15" watercolor paper, 16 pan watercolor set, and a round camel hair #8 or #10 brush. Permanent black pen for drawing. Tissue and water. White crayon for resist, optional.

- **With Tempera:** 12" x 18" piece of quality construction paper or bristol board, primary colors, secondary colors, turquoise & white. Permanent black pen for drawing. Disposable palettes, paper towels and water.

- **With Acrylic:** 12" x 16" canvas on a table easel, primary colors, secondary colors, turquoise & white. A pencil for drawing, and disposable palette or paper plates. Lots of paper towels and water. Acrylic brushes need to be sturdy. Use synthetic acrylic brushes.

Find Your Sailboat

Choose one sailboat to draw. Depending on your age and experience, you may want to draw more than one.

The acrylic painting that I did (above) has three sailboats—one in the foreground, middle ground and background. Note how each is bleeding off the sides of the canvas.

If you have sailboats nearby, consider drawing one outdoors, "*en plein air*" (French, literally: "in open air"). Or find a photo of one that is as complicated as you can handle. Be sure the photo has overlapping sails.

Some of the old ships are really fun to draw… the Mayflower for example.

So many decisions.

- Will your canvas be horizontal or vertical?
- Your intuitive artist-self gets to decide.

Hint: Envision where your masts will be. (They hold the sails up.) How much room will you need for them?

Drawing the Sailboat

The step-by-step process is the same for all mediums.

1. Draw the hull.

 Draw the hull (the base of your boat) so it is **not touching the bottom** of your canvas.

 Draw the details of the hull.

 Add any windows or other visible features.

 Don't draw people. We will save that for another lesson.

2. Draw the sails.

 Think of the sails as big irregular triangles and rectangles.

 Draw the sail that's closest to you first.

 Sails bend and fold with the wind … so carefully draw the shape of each sail, one at a time.

 Sail shapes will overlap; one in front of the other.

3. Next, draw your masts (the poles that hold the sails up).

4. Draw a horizon line **behind** the boat where the sky meets the water.

Painting the Sailboat

Start thinking about colors and the time of day you want for your painting.

Ask yourself:

"Does my painting take place in early morning? Mid-day? Sunset?"

The time of day you choose will help you decide what colors to use.

Sunset, Corinne, tempera

Watercolorists

PREPARATION

Refer to *Essential Ingredient 3, Watercolor Techniques.*

Tempera/Acrylic Artists

PREPARATION

Refer to *Essential Ingredient 2, Creating New Colors with Paint.*

5. Paint the sky first.

 Do you want to have a clear blue sky? A turbulent green-blue stormy sky? Maybe a sunset sky? You pick.

6. Paint the water.

 Paint the water behind the boat and below the horizon line.

 Mix colors right on the surface of the water.

 If you like, the water can look alive and moving.

Take a break and let your piece dry.

7. Paint the hull of the boat.

 Note: Let's stay away from black as it will muddy up the painting.

 You know how to mix brown using the 3 primary colors. Use brown instead.

8. Paint the sails any color you want.

 - **Tempera/Acrylic Artists:**

 If you want the sails to be white, paint them white with a little bit of color so they become off-white.

 - **Watercolorists:**

 If you want, use a white crayon to make fun designs in the sails before you paint them. The crayon will resist the water in the paint, allowing your design to remain.

Option for Tempera Artists:

 After your painting is dry…

 Go over every line with a permanent black marker to get your details back.

Thank you, Carol, Angela, and Robert. I love that no two pieces are the same. We each have to pursue our own path in this artistic journey.

REFLECTION ZONE

Would you like to do this project again with a different type of paint? How would you change your painting?

What did you experience while you were painting? From 1 to 10, how did you feel? (with 1 = totally frustrated and 10 = complete joy, freedom or "being in the zone")

Critique: After responding to the above reflections, everybody shares their piece with the group. • Does it feel like you are developing your own style? • Describe your piece. What do you like best about your piece? • Tell someone what you like best about their piece.

STILL LIFE
CUT PAPER

à la Lichtenstein

Cut Paper Still Life Collage, Julian Kubisty, H.S., mixed media

Supplies:

- 5 to 7 objects for your still life, such as a bottle, fruit and plants
- construction paper: black and greys
- scissors
- thick black marker
- glue stick
- white 12" x 18" or larger construction paper for the background
- photocopies of patterned black and white papers to be used for object shapes

The POP artist, **Roy Lichtenstein** is renowned for multiple achievements in the time-line of modern art.

The 1960s were a time of change. The "Mad Men" boom in advertising made consumer products visible as never before, on billboards, in magazine ads and on TV. Reflecting this, the kings of Pop Art, Andy Warhol and Roy Lichtenstein created remarkable art focusing on ordinary objects. From soup cans to super heroes, pop artists enlarged, exaggerated and repeated common everyday items that had never before been thought of as art.

Best known for his comic-strip inspired art, Lichtenstein was also fascinated with how repeated patterns could be used to create texture. **Texture** gives a 3D feeling to 2-dimensional objects on a flat surface.

In the abstract collage below, the rough feel of the fabric-like background is strengthened in contrast to the smooth surface of the silver-gray frame. Feelings of flow assist the illusion that thick paint is actually falling and about to splat somewhere below.

Painting on Canvas, 1983, Roy Lichtenstein
Courtesy of D. Schaff private collection
Limited edition: 15/60, woodcut/lithograph/screen print/collage

It is time, now, for you to make a still life-collage inspired by the patterns, cut papers and textures of Pop artist, Roy Lichtenstein.

PREPARATION

Refer to *Essential Ingredient 10, Drawing with your Scissors*.

Choosing Still Life Objects

1. Place 5 to 7 still life objects in front of you, such as a bottle, fruit, a kettle and/or vase and flower. You can even line them up.

 You will arrange these objects later to create your own composition.

Drawing a Contour Line (without a pencil)

2. Point to one object and draw a line with your finger around it in the air.

 This is called a CONTOUR Line.

 Now, in the same way, draw the Contour of that same object, pointing at and touching the paper you are going to cut.

Use one piece of black, grey or patterned paper at a time.

Drawing with Scissors

3. Cut the contour shape of that object with your scissors.

 You are drawing with your scissors. If you cut a line you don't want, just trim and do a little cosmetic surgery with your scissors to repair.

4. Cut out another object, as above.

 Be sure it is the correct size in relation to the 1st object.

5. Cut out all the objects using 3 or more different papers.

 Use a variety of black and white patterned pieces, along with black and grey construction papers.

6. Place the cut objects in a row in front of you.

PREPARATION

Refer to *Essential Ingredient 11, Recipe for Drawing a Still Life*.

Arranging Your Objects

7. On the 12" x 18" background paper, arrange your objects over and over until you come up with an interesting still life.

 Do not place them in a row.

 Consider which object will be front and which behind.

 Keep rearranging the puzzle pieces until you like the composition.

 - Remember to **OVERLAP**.
 - The objects in front are closer and lower on your paper.
 - They are in the **FOREGROUND**.

 Once arranged, glue the objects.

8. Glue all of your objects onto a background white paper or patterned paper.

Start by gluing the objects in back first.

OR

9. Add additional details with cut paper after you have glued the objects.

10. Use a black felt tip marker to draw details on your objects.

11. Draw patterns in your background.

Note: If you have a plant in your still life, look at it carefully.

Notice how the lines in leaves are organic. Life-like, not straight.

This is true with all living things; no lines are straight!

REFLECTION ZONE

How did you like drawing the contour line of an object with your scissors?
How many different still life compositions did you arrange before you glued down the one you liked?
Look up pop artist Roy Lichtenstein and Pop Art? What did you find out?

HARLEM RENAISSANCE FACES
CUT PAPER

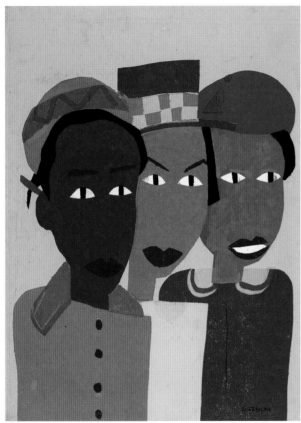

William H. Johnson, *Three Friends,* 1944-5
Courtesy of the Smithsonian American Museum,
Gift of the Harmon Foundation Museum

William Johnson (1901-1970) was an African American artist born in a poor area of South Carolina. He was first introduced to art through cartoons. Johnson was 17 during the Harlem Renaissance, which was the rebirth of African American Art. That's when he moved to New York City to study art. He became highly respected at the National Academy where he earned many awards.

He studied art abroad in France, after which his art became more expressive. He also lived in Scandinavia and was inspired by simple folk art there—colorful art that is more tribal or primitive. You can see the influence when you search William Johnson's Art on the internet.

In 1939, before World War II, the depression was still going on. He left Europe and returned to the United States to work for the Works Progress Project. Under the New Deal plan, artists were given jobs. His job was teaching at the Harlem Community Art Center.

At the time, cut paper was an affordable art material (or medium). Johnson produced many paintings and cut paper collages of African Americans.

We will use the same material in this activity.

PREPARATION

Refer to *Essential Ingredient 10, Drawing with your Scissors.*

Supplies:
- scissors and glue stick
- 3 pieces of skin tone construction paper 6" x 12"

 We are of many cultures and colors, so if you want, use three different skin tones.
- varied colored construction paper
- scraps of wrapping and varied textured/patterned papers (example: African textile papers)
- 12" x 18" paper for background

1. Make three heads using skin tone colors.

2. For each one, cut a 6" x 12" skin tone paper into two parts, as follows:
 - 1- 9" x 6" piece
 - 1- 3" x 6" piece

3. Make the oval heads first, using the 9" x 6" papers.

4. Use the 3" x 6" leftover skin tone paper to make the necks.

 Glue the necks to the heads. We look funny without necks!

PREPARATION

Refer to *Essential Ingredient 8, The Face Recipe.*

5. Eyes

 Make the whites of the eyes by trimming the corners of a smaller rectangle to create an elongated oval.

 Glue them in the center of the head according to *The Face Recipe*.

 Trim off the corners of a small circle to create the iris, the colored part of the eye.

 Are you blue-eyed, brown-eyed or hazel?

 Place a small black round pupil in the center of the iris.

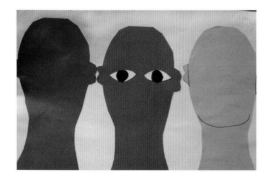

6. Ears

 Make some small oval ears and glue them to the sides of the heads.

 Remember where they are in relation to the eye.

7. Mouth

 Draw the shape of the lips with your scissors.

 You don't need a pencil. Glue on the mouth.

8. Place your 3 head shapes on the background 12" x 18" paper.
 - Decide to place the background paper either vertically or horizontally.
 - The 3 faces may overlap.
 - Some faces may be taller or farther away.
 - Before gluing your heads to your background paper, move them around to create an interesting grouping.

9. Glue your three heads to the background 12" x 18" paper.

10. Create colorful, interesting FRIENDS.

 Cut out and glue on:
 - eyebrows
 - eyelashes
 - nose
 - hair
 - jewelry
 - clothing
 - hats

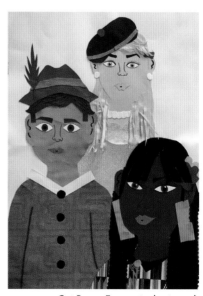

Cut Paper Faces, student work

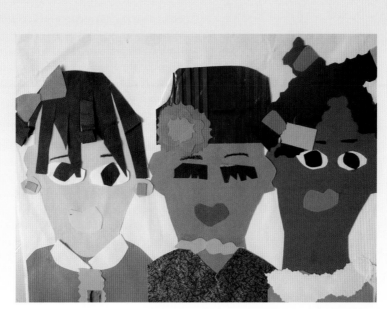

Cut Paper Faces, student work

REFLECTION ZONE

Wow. I love the flexibility of drawing with scissors. How did you feel?

Think of your very best friends. Do you have friends from different backgrounds or cultures?

REALISM, BACK OF THE HEAD
DRAWING

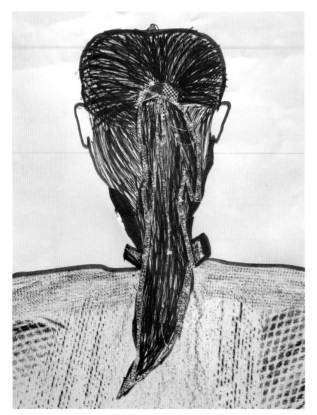

Portrait of Lekha, Neeraj Jain, 5th grade

Andrew Wyeth was an American artist who painted in a style referred to as **REALISM**. His father, N.C. Wyeth, was an illustrator who encouraged his children to become involved in the arts and hired tutors to promote creativity and imagination in their education. Film, poetry and music were constants in the Wyeth home.

Andrew was an unhealthy child, so he was home-schooled. He was sheltered and somewhat isolated from the outside world. He drew before he could read. Art was his first language.

His father was his only teacher and instructed him in representational drawing, figure drawing, and the use of watercolors and egg tempera, which is made with egg yolks and color pigments.

Andrew Wyeth used egg tempera for many of his famous paintings. Egg tempera goes back to ancient times, as far back as the Egyptian Temples.

His ability to create lights and shadows made his portraits almost photographic. The tempera painting, *Farm Road* is a good example, showing the back of a young woman's head. This piece is part of a series of 240 paintings of one model, Helga Testorf. Wyeth met Helga on a neighboring farm and painted her over a 15-year period.

Wyeth's paintings depicted his favorite scenes of the farms and people near him in both Pennsylvania and Maine. In his lifetime, Wyeth's honest and accurate representations of life around him were respected in exhibitions throughout the United States. His works hang in museums across the country and abroad.

Wyeth was the first visual artist to be awarded the medal of freedom by a U.S. President.

To all beginning artists:

It's not unusual to feel threatened by the prospect of drawing a face or body. The fear often dates back to about age 9 to 12, when we felt strongly or got the message that we cannot draw realistically. The fear of failure can actually cut us off from developing our artistic ability.

If that's true for you, don't worry. Many of my students have felt exactly the same, and all of them successfully learned to draw—and had fun doing so. You can move forward from wherever you left off. Let's pick up from that level now, with this activity.

Supplies:

- a model sitting in a chair
- black thick and thin markers
- 12" x 18" white paper
- black crayon for texture rubbing
- scratch paper

PREPARATION

On the internet, find the painting "Farm Road" by Andrew Wyeth.

Drawing from a Model

Please have a model sit in a chair so you can view the model from the back of their head (as Wyeth viewed his model for "Farm Road"). If there are several people in your group, take turns being the model. Enjoy the community.

1. Place your paper so it is VERTICAL. Computers refer to this as "portrait" mode.

2. Using the thick black marker, start on the left side of the paper.

 Draw a continuous line along the top of the shoulder to the top of the head.

 Are the hairs flat on top or do they have an interesting shape?

3. Continue your line around the top of the head, down the neck, to the other shoulder and off the right side of the paper.

4. If you see the ears, draw them.

PROPORTION

Shoulders are TWO heads wide and will bleed-off (go off the sides) of the paper.

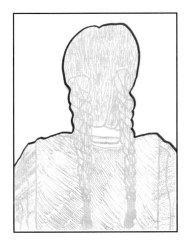

The Hair

5. Add important lines for the hair with the thick black pen.

6. Switch to the thin black pen to draw every hair.

 The hair lines are probably not straight.

 Look carefully, then draw ORGANIC (life-like) lines.

Clothing

7. With a thick marker, draw the main lines of the clothing.

8. Use the thin black pen to draw every stitch and detail.

 Once every detail is done, you will use the side of the black crayon to make rubbings and create textures to fill in some of the large shapes, for example, in the model's clothing.

Making Crayon Rubbings to Create Texture

Texture is the way something feels, the feeling of fur versus the feeling of silk or rough cloth. Texture, in art, is a technique that gives a 3-dimensional feeling to objects on a 2-dimensional flat surface, like your drawing.

First, Practice Making several Crayon Rubbings

Look for items around you that have texture. If you've never done this before, try a coin. Use a black crayon. Place a coin under your scratch paper and gently rub your crayon over it. See the texture it creates? Do it again and press hard with the crayon to get a more intense black.

The tread on the bottom of athletic shoes makes a great rubbing. The kitchen is also great place to look. Do you have a plastic tray with an interesting raised design? I just found the top of a vitamin bottle that's not smooth. How about a spatula. It has texture.

Place the spatula under a piece of paper and gently rub your crayon on the paper over it. Is that a pattern you like?

For an example of what you can do, look back at the "Portrait of Lekha" on page 98. Can you see where the artist added texture to the model's clothing? How many textures did the artist add to his drawing?

9. Practice 5 texture rubbings. Decide which ones you like.

Make Crayon Rubbings on Your Drawing

10. After you've practiced and decided on a few textures, you can now use them on your drawing.

Place part of your drawing on top of a textured item you chose.

Rub over the item with black crayon to give texture to parts of the model's clothing you've drawn.

REFLECTION ZONE

Was there a time when you felt you couldn't draw perfectly so you stopped?
Tell about that frustration.

Did you create a successful "back of the head portrait"?
Tell about your experience.

ACTIVITY 18 ▲

NATIVE NORTH AMERICAN PORTRAIT
COLLAGE

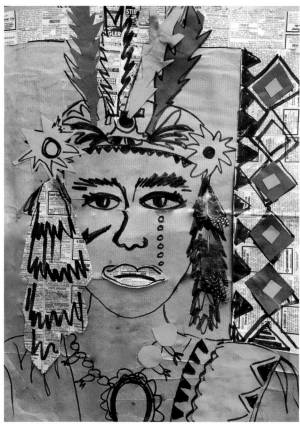

Native North American, collage

Supplies:
- black thick marker
- brown grocery store paper bag
- classified newspaper section (small print, no pictures)
- dark brown and turquoise construction paper
- natural colored feathers
- scissors, glue stick, white glue

On the Internet, search:
- Native American images
- Photocopy one face with every wrinkle

Also search:
- Indian headdress/war bonnet images
- Native American artifact images
- turquoise squash necklace
- Native American Indian traditional clothing images
- Find photos of a leather shirt, jacket or vest

Collage is a word that comes from the French word *coller* which means "to glue."

We will be using **recycled** papers.

Native American Art depicts a culture that was the foundation of our country.

Take the grocery bag and cut the base out and take the handles off.

Fold the remaining brown bag in half. Cut. You will now have two rectangles approximately 15" x 19".

Use 1 of these, per person, for this activity.

PREPARATION
Refer to *Essential ingredient 8, The Face Recipe.*

1. Place your brown paper vertically.

2. Looking at the face you printed, draw the nose. With the marker, between the top and bottom of your paper, start by drawing just the lines for the nose.

 Notice the length of every line and where the lines touch one another.

 By placing your face a bit off center, your portrait will be more interesting.

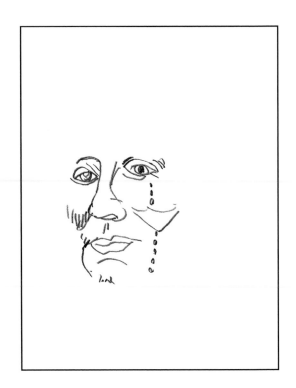

3. TURN YOUR PAPER UPSIDE DOWN

 1st: Notice the size, shapes and length of the lines you see.

 Do not get caught up trying to find upside-down parts of your image, like the eyes or mouth. If possible, do not think "eye" or "nose." That way you won't let your thinking "left-brain" take over and make you stuck in ideas of what something should look like.

 2nd: Start with the facial features. Draw every organic (life-like) line you see. Look at each line in relationship to the next.

 3rd: Draw the outside shape of the head.

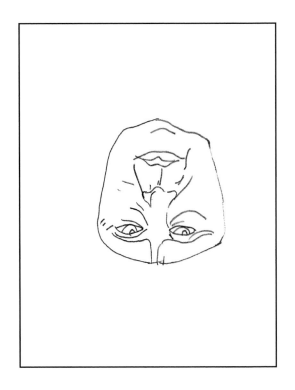

4. Turn your paper so that the face is right side up.

5. Draw an Indian headdress, also known as a war bonnet, so that it touches the top of the paper.

 • Be sure it is rounded to the shape of the top of the head. The top of the head is not flat.

6. Draw the neck and upper torso with the shoulders bleeding off the sides of the paper. Be sure the shoulders are two heads wide, so they are in PROPORTION.

7. Draw traditional Native American clothing and add fringe, jewelry and more details.

 Incorporate some of the designs from when you searched Native American artifacts.

Collage

8. Cut newspaper SHAPES. You are drawing with your scissors. Use a glue stick to place newspaper print in at least 4 areas around your collage.

9. Cut shapes out of both the turquoise and brown construction paper. Place them on your collage until it is balanced with a nice amount of newspaper, brown, and turquoise paper. Glue the turquoise and brown shapes onto your collage.

10. With the black marker, draw details on top of glued paper shapes.

11. With the marker, blacken in some of your shapes to cover, for example, 10% of the collage.

12. With white glue, place some natural colored feathers to add more texture.

REFLECTION ZONE

How did you feel using the upside-down method of drawing?

Were you better able to look where lines intersect and touch one another?

What design ideas did you use from your internet search to create Indian clothing?

Try holding your picture and looking at it in a mirror.
What would you change or add to it?

ACTIVITY 19 ▲

EGYPTIAN ART PROFILE
OIL PASTELS

Art tells us about a culture. When we think of Egyptian art, the first things that come to mind might be the pyramids of Egypt, golden treasure or mummies.

The Language of Art

Ancient Egyptians used a pictorial language called "hieroglyphics."

Other civilizations, such as the Mayans, used a visual language to tell about their culture. Art is the universal language linking us to all cultures across time. Prehistoric cave paintings are the oldest example.

PREPARATION

Refer to *Essential Ingredient 8, The Face Recipe.*

In Egyptian portraits, heads were mainly shown in profile view, from the side. The nose, ear and crown are shown as you would expect,

However, do you notice anything different about the Egyptian eye?

Profile

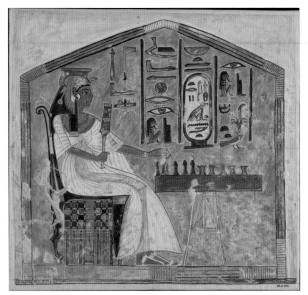

Queen Nefertari Playing Senet,
Nina de Garis Davies, facsimile copies
Courtesy of the Metropolitan Museum of Art
Rogers Fund, 1930

Supplies:

- 12" x 18" construction paper, purple or red, placed vertically on newspaper
- a black thick marker
- oil pastels
- gold paint pen

Painted Shroud Fragment, linen
1st century BC - 1st century AD
Courtesy of the Metropolitan Museum of Art
Purchase, Fletcher Fund and
The Guide Foundation Inc. Gift, 1966

Background Knowledge

Search the Internet for Egyptian Art profile images.

Select and print one that energizes you.

Real life profile

In primitive Egyptian profiles, the eyes are often in "frontal view," looking at you.

The realistic profile above shows the side view of the eye. The woman's eye is looking forward (in the same direction the nose is pointing).

Frontal

Mummy Mask, AD 60-70
Courtesy of the Metropolitan
Museum of Art
Rogers Fund, 1919

1. Look at the Egyptian profile you printed.
2. Place your paper vertically.
3. In the middle of your paper, begin drawing your profile line with the black marker.

 Be sure to leave at least the top third of the paper free for the headdress/crown.

4. Draw the eyes and mouth.

 Add the contour line of the eye.

 Add the lips.

 Think of irregular hearts when drawing the lips.

5. Draw the chest.

 The upper torso should touch both sides of the paper.

 Draw the shoulder from the front viewpoint.

 Add elaborate detail lines of the clothing.

6. Draw the head crown.

 Once all the facial features are complete …

 Using the black marker, draw the head crown with all of the line details.

 Yes, many crowns have cobras, as Egyptians honored snakes.

Be sure lines are touching all sides of the paper.

7. Add gold.

 Egypt had a lot of gold. So once your black drawing is complete…

 Use your gold paint pen and go over some of the black detail lines.

 Fill in some shapes with gold.

About your Gold Paint Pen: *Be sure you read the directions and test your gold pen before using it, so it doesn't "blob" when you shake it!*

8. Add color using oil pastels.

 Color in the shapes of your drawing. Press heavily so the paper does not show. Think of this as painting with lipsticks.

 Limit your palette to no more than 6 colors.

 The colors are fun to mix/blend together.

 The black and rust earth tones in Egyptian art were made from the earth—ochre from the desert, gypsum or soot—so be sure to include them!

 Repeat color choices to *unify* your picture.

 Remember black and white are not colors, so try mixing white into the colors to create tints or black to make shades.

 This will give a sense of dimension/depth to your piece.

9. Cover the entire piece of paper with **opaque** (cannot see-through) oil pastel.

10. Go over any black marker lines with black oil pastel, where needed.

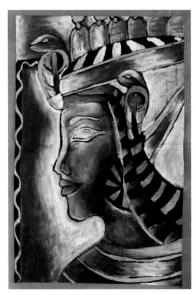

Egyptian Profile, 6th grade, oil pastels

Optional Activity: Black and White Egyptian Profile Drawing

Background Knowledge

Search the Internet for Egyptian black and white art.

Select one or more images that interest you.

Follow steps 1 thru 6 from the first part of this Activity.

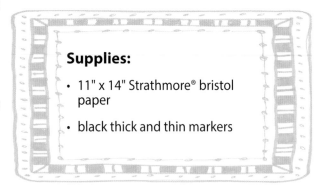

Supplies:

- 11" x 14" Strathmore® bristol paper

- black thick and thin markers

Do the Optional Activity using white paper and black markers.

And then…

- Create a patterned background, inspired by artifacts and designs that you find from Egyptian art.

- Darken in 50 % of the shapes you have created.

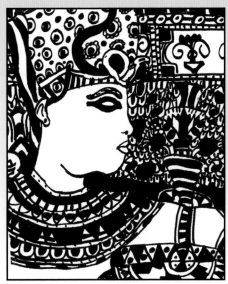

Egyptian Profile, markers

REFLECTION ZONE

Isn't it wild that you made the eyes looking forward, at you, even though you were drawing a profile?
If you used oil pastels, was it fun blending the colors together? What was challenging? What did you learn?
If you invented a pictoral language, what would be the first thing you'd say? How would you say it in pictures?

ACTIVITY 20 ▲

GLUE LINE AND CHALK
DRAWING

This is a two-day activity

Choose Your Subject

Activity 1: Still life
 or
Activity 2: Be King or Queen for a day

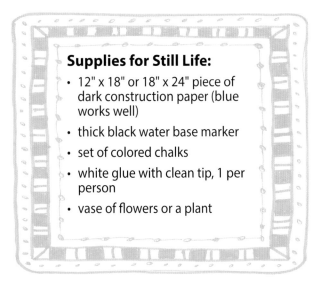

Supplies for Still Life:
- 12" x 18" or 18" x 24" piece of dark construction paper (blue works well)
- thick black water base marker
- set of colored chalks
- white glue with clean tip, 1 per person
- vase of flowers or a plant

Setting Up Your Workspace
… for either Activity 1 or 2

1. Choose a space to work where you can safely leave your piece overnight.

 Once you start the glue process, you do not want to move your piece until it is completely dry.

 Note: First, you will draw your subject with a marker.

 Next, when your drawing is complete, you will carefully be covering every black line with a line of white glue.

 Later, you will use chalk to add color to your piece.

Activity 1: Drawing a Still Life
PREPARATION
Refer to *Essential Ingredient 11, Recipe for Drawing a Still Life.*

2. Set up a vase of fresh flowers or a plant.

3. Place your construction paper vertically (short side on top).

 Note: Do not draw your black lines too close to one another, or the glue will run together.

Drawing with Marker

4. With the thick black marker, **draw the plant or flowers**.

 Draw the shape of leaf or a flower that is closest to you first.

 Draw the entire arrangement, shape by shape.

 Lines and shapes will almost touch the top of the paper.

5. Draw a fun container to place your arrangement in.

 Note: If leaves or flowers are on the inside of the container, you will not see the entire top of the container.

6. Invent and draw a tablecloth below and behind your container.

 This will "ground" your flower arrangement.

7. Fill your table cloth with patterns.

Drawing the Background

8. Divide the space behind your objects into thirds by placing 2 vertical lines from top to bottom.

9. Create fun patterns, like wallpaper in all three areas.

Drawing with Glue

10. Slowly cover each black line with a steady flow of white glue.

 If you make a blob, just leave it. Don't try to blot any glue.

 Note: If by chance you have drawn a black line you don't want, don't go over it with white glue.

 The colored chalk will cover any lines you don't want.

 Allow your piece to dry, at least overnight.

Adding Chalk Color

11. Color the inside of every shape with chalk. Mix and blend colors within the glue-line walls.

The *glue walls* make it fun to color with chalk.

Enjoy your own color palette.

You may "rub" the chalk within the black line shapes with a paper towel.

Better yet, use your fingers!

Still Life, Kelley Vandemoortel, 6th grade, chalk drawing

Activity 2: Be King or Queen for a Day

Supplies for King or Queen for a Day:

- 12" x 18" or 18" x 24" piece of dark construction paper (blue works well)
- thick black water base marker
- set of colored chalks
- white glue with clean tip, 1 per person
- King or Queen playing card

1. Remember, choose a workspace where you can safely leave your piece overnight.

Choosing a Playing Card

2. Find and choose a playing card of either a King or Queen.

 If you don't have a deck of cards, find a card you like online and print it.

3. Place your construction paper vertically (short side on top).

 Note: Do not draw your black lines too close to one another, or the glue will run together

Drawing with Marker

4. The Crown

 Starting near the top of the paper, draw a crown.

 The crown will be curved.

 It won't be flat on the hairline.

5. The Face & Hair

 Draw black lines for the eyes, nose and the mouth.

Take time to carefully draw lines. Notice where they touch each other.

Draw the lines of each hair.

6. The Shoulders

 Draw the shoulders going off the sides of the paper.

7. Drawing the Hands

 Note that the hands of your King or Queen are not in proportion.

 You may draw them small or enlarge them.

 For this drawing, please choose for your King or Queen not to hold anything.

8. Clothing

 Draw black lines to create beautiful designs and rich details for your clothing.

Drawing with Glue and Adding Color with Chalk

Refer to steps 10 and 11 in Activity 1, above, to complete your King or Queen.

REFLECTION ZONE

Did you ever think you would use glue in a drawing?
How was it using white glue and colored chalk to create a piece of art?

Streets artists use chalk all the time to express themselves.

Did you mix and blend chalk colors within the glue-line walls?

What other combination of medium/material might you use to create the same composition?

Example: Would you like to create a king or queen with acrylics and jewels?

ACTIVITY 21

▲ ●

WESTERN COWBOY BOOT
MARKERS

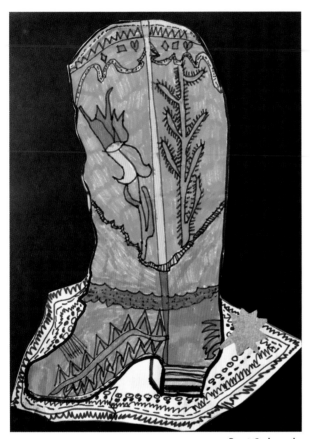

Boot, 3rd grade

Cowboy boots are pieces of art. Each individual piece of colored leather is stitched carefully together so they will last for years.

Note: The lines you draw will be organic, lifelike. Over time, cowboy boots stretch to comfortably conform to the cowboy or cowgirl's foot.

Contour Drawing is a technique where you draw an outline of the subject.

Contour is a French word that means "outline."

Supplies:

- sideview photo of a colorful western boot or better yet, a real boot!
- bandana or patterned cloth, to place under the boot
- black markers, thick and thin
- colored markers
- white 12" x 18" paper, placed vertically
- black 12" x 18" construction paper to glue finished boot on
- glue stick and scissors
- optional: foil for spur

Warm Up
Contour Drawing with your Finger

Using a Photo

With your "pointer finger," slowly draw the outside contour line of the boot on the photo.

Using a Cowboy Boot

Place the boot at eye-level. Pointing at the boot, slowly draw the contour line around the outside of it, in the air or actually touching the boot.

Draw your Cowboy Boot

1. Place your white paper vertically (short side on top).

2. Draw the bottom of the boot first.

 Start about 3 inches from the bottom of the paper.

 With a fat black marker, draw the heal and the bottom of the boot.

 Then draw the line that wraps around the toes.

112 ART FOR ALL AGES

3. Next, draw the tall sides and the top of the boot.

4. Look at the angle of the heal lines in the next image.

 Add similar lines to your drawing to make the heal look 3-dimensional.

Add a strong supportive line for the sole of the boot.

Now make a line outside the top of your boot.

This will also make your boot look 3-dimensional, so you can put your foot right in!

5. Design your own boot.

 Draw the vertical seam line where the leather is sewn together.

 Use thick black lines to draw all the important lines and shapes.

You are the designer and must show every stitch with thin black lines so your boots will sell.

Optional: Look at several other images of cowboy boots.

Add details you like from those images to your own drawing.

6. Draw the bandana.

 Place a bandana or patterned cloth on a table so it wrinkles and folds.

 If using a real boot, place the boot on the bandana.

 Note: The sides of the bandana are not straight lines.

With the thick black pen, first draw a line behind the boot on both sides.

(This will make it look like part of the bandana is behind the boot.)

Below the boot, the line of the bandana may angle down with the sides showing. The cloth appears to fall in front of the boot. That's because objects in the front of a drawing appear to be below the objects in back.

By making the bandana shape around the boot, your boot will look like it is on top of the fabric.

Now look at the fabric and patterns of the bandana.

Using the **thin** black marker, draw the border of the bandana, and add patterns and details.

Color your Boot

7. Use colored markers to color **only** the entire cowboy boot.

 Limit your colors to no more than four of your choice.

 You do not have to use the same colors as the boot you are looking at.

 Do not color the bandana. It remains black and white.

Finish your Boot

8. Cut out your boot and bandana drawing.

9. Glue the cutout to the black background paper, or choose a different color paper that you feel shows off your boot.

 Optional: Using foil or metallic paper, cut out a star shaped spur and glue it on the back of the boot. Do you know what spurs were used for?

REFLECTION ZONE

What did you think of contour drawing with your finger to warm up?

Did you make any lines you didn't like and then make them into something? Did you make a mistake into an opportunity?

We can call this a "happy accident."

ACTIVITY 22

SHOES
DRAWING

Athletic Shoe, 3rd grade

Supplies:

- athletic shoe
- 12" x 12" quality white paper
- thick and thin black markers
- colored markers
- note: **no** pencil or eraser

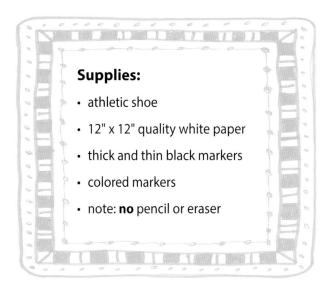

PREPARATION

Refer to *Essential Ingredient 5, Gaining Perspective.*

Footwear Options

An athletic shoe is best for your first shoe drawing because it has fun details. So, if you are wearing your favorite walking, hiking, basketball or other sports shoes, take them off.

Or find or borrow one and bring it to your workspace.

Place one shoe at eye level in front of you.

It may need to be on a box to make it eye level.

Contour Drawing is a technique where you draw an outline of the subject.

Contour is a French word that means "outline."

Warm Up
Contour Drawing with your Finger

Looking at the shoe from the side, with your "pointer finger," **slowly** draw the outside contour line around the shoe in the air or actually touching the shoe.

1. Draw the **side** view.

 Be sure to leave an inch or two at the bottom of the paper so the shoe doesn't touch.

 Tip: Unless they are right out of the box, all lines on shoes are ORGANIC (lifelike). There are no straight lines.

 With a thick black marker, slowly, draw the bottom of the shoe. Is it a straight line? No.

 Draw the line of the back of the shoe as it comes up from the heal.

 Now draw the entire CONTOUR LINE (outside line) of the top of the shoe.

 Your eye is like a ping-pong ball going back and forth, from looking at the shoe to your paper.

Note: This is *your* shoe company. You can add a logo if you want.

A logo is a symbol or picture that represents your company.

2. Add tread lines to the sole of the shoe.

 Notice the different lines, angles, and thickness of the treads.

 What if you are exercising, running, or playing sports? You need good arch and foot support. This is why people pay the "big bucks" for athletic shoes!

4. Draw the **top** view.

 Draw your shoe from the top, as if you are flying above it.

 This is the "birds-eye" view.

 For drawing this viewpoint, it is easier if you place the shoe on the floor below, so you get the TOP view.

 First draw the outside contour line.

 Then, once again, add every stitch and detail to the top of the shoe using thick and thin black markers.

3. Now add every line and shape you see on the side of your shoe.

 You are now a shoe designer. In order to sell your product, you must render (draw) all of the details.

 Use the thick black marker for the important lines.

 Then use the thin black marker for details, such as patterns and stitches.

 Although functional, the design of your shoe is also aesthetic.

Try not to put any words in your art,

otherwise that strong word brain will take over.

You are the inventor and designer of the best shoe company.

If you make a line you don't like, just make it into something.

We call this a "happy accident."

Optional: Draw the front or back view of your shoe, using the same steps you followed for the side and top views.

5. Add color.

 Use colored markers to color the shoe only.

 Limit your colors to no more than three of your choice.

 You do not have to use the same colors as the shoe you are drawing.

 Remember, you do not have to count black as one of your choices.

 Why? Because black is not a color.

Optional: Create a background for your drawing In the background, create a pattern of repeated shapes (like wallpaper).

Use only black and white markers.

Your pattern might be inspired by some design on your shoe, even the tread on the bottom.

Multiple Shoes, Reid Miller, 3rd grade

REFLECTION ZONE

How did you feel learning to look, feel, and draw using a contour line?
What would the name of your shoe company be?
Did you show all the details and fine craftmanship that will make your shoe sell?
Did you draw any lines you didn't like and then make them into something? Did you turn a "mistake" into an opportunity?

LANDSCAPE, ONE-POINT PERSPECTIVE
TEMPERA PAINT

Supplies:

- 8" x 12" white or yellow construction paper
- paper plate with tempera: yellow, red, blue, green, turquoise, magenta
- white paint on separate plate
- black crayon
- round camel hair brush, #8
- water, paper towels
- newspaper to protect table

Trees: No more round circle apple trees.

Think of a tree as a long arm with fingers branching out.

Each finger has beautiful leaves.

Get the picture?

Remember: In a landscape, things that are closer are lower and larger.

PREPARATION

Refer to *Essential Ingredient 5, Gaining Perspective.*

Drawing a Horizon Line

1. The horizon line is where the sky meets the earth.

 Place your paper horizontally.

 Don't put the horizon line in the middle. Place it higher, as in *Example 1* or *2*, on the next page.

 With a black crayon, so you can hardly see it, gently draw the horizon line across your paper.

Creating a Road

2. Place a point on the horizon line that is not centered: either off to the right or left.

3. Place two dots on the **bottom** of the paper, also not in the center and about two or three inches apart.

4. Connect the dots:

- From one of the dots on the bottom of the paper, make a line that connects that dot to the dot on the horizon line.
- Connect the other dot on the bottom of the paper to the dot on the horizon line. This will be your "yellow brick road."

Example 1

Example 2

Drawing Your Trees

5. With your black crayon, draw the largest tree that is in the **foreground** (closest to you).

 This tree should touch the bottom of the paper, but not touch the top.

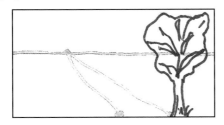

 The closest big tree can be on either side of the road.

 Not all of your trees need to be the same kind.

 … If you like, throw in a palm tree for fun.

6. Draw a second tree a little farther away.

 Place the bottom of the tree about 2" above the bottom of the paper. Have this tree touch the top of your paper.

 This tree is in the **middle-ground**.

7. Place a **pond of water** below the horizon line.

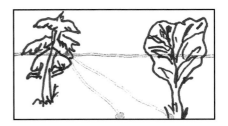

8. If you have room, draw a third tiny tree far-far away in the **background** on the horizon line.

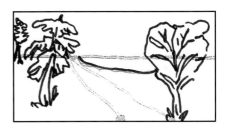

PREPARATION

Refer to *Essential Ingredient 2, Creating New Colors with Paint.*

Painting

9. Place your landscape on newspaper. Place it so you can paint off all sides of the paper.

10. Paint the sky.
 - Mix magenta with a touch of turquoise to make a soft purple. Add some white.
 - Paint the sky.

11. Paint the road.
 - Mix a light yellow (white and yellow).
 - Paint the road.

12. Paint the pond.
 - Mix the blues. Turquoise would be nice.
 - Paint the pond.

13. Painting the tree trunks.

 - Mix brown on your plate.

 The three primary colors: red, yellow and blue make brown.

 Do you see a shortcut?

 If yellow and blue make green, then green and red make brown.

 - Paint the tree trunks.

14. Paint the grass.

 - Mix lighter greens using yellow and green.

 Try turquoise and yellow to make a green.

 How many greens can you make?

 - Paint the grass with different greens.

15. Paint the many greens in your trees.

 Can you make a blue-green?

Take a break. Let your painting dry completely.

16. Outline the important lines of your landscape with black crayon.

Press heavily.

 - Carefully draw the outside/contour of the trunk, branches, and every leaf in the trees.

 - Draw the horizon line where you see it behind the trees.

 - Outline your pond.

 - Outline your 1-point perspective road.

 - Make each blade of grass. Pieces of grass in the foreground are larger.

Landscape with Trees, Corinne, tempera paint

REFLECTION ZONE

Together show and tell about your work. Everyone gets a turn. Where does your road go? Point to the vanishing point dot you made at the start.
Where is the foreground?
Is there a tree in the middle ground?
What time of day is it in your painting?

STILL LIFE
OIL PASTELS

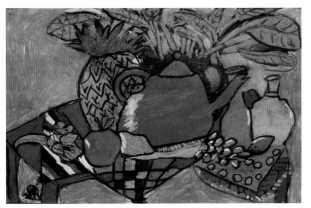

Still Life, Sabina Karaba, 3rd grade, oil pastels

Supplies:

- still life objects
- 12" x 18" purple or red construction paper placed on newspaper
- viewfinder (that you will make)
- thick black marker
- oil pastels
- paper towels to clean ends of oil pastels
- white oil pastel for tints
- black oil pastel to go over all lines upon completion
- optional: gloss medium and sponge brush for protective coating

PREPARATION

Refer to *Essential Ingredient 11, Recipe for Drawing a Still Life.*

1. Make a viewfinder.

 It helps to have a viewfinder to focus in on only a part of the still life, so it is not so overwhelming.

 It is easy to make one. Simply cut a rectangle out of a piece of paper or cardboard.

2. Set up a still life on top of a table or box with a cloth on it.

 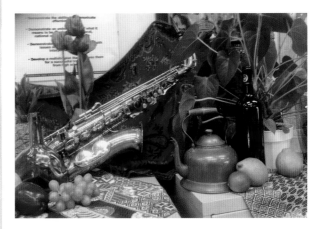

3. Place your paper horizontally or vertically, depending on your still life.

 Use your viewfinder to focus in on a portion of your still life.

 Here's how to do so:

 - Close one eye. Hold the viewfinder up to the open eye.

- Carefully move the viewfinder away from the eye so you can zoom in on the part of your still life that you want to place on your canvas/paper.

Now put your viewfinder aside and hold your 12" x 18" paper in front of the portion of the still life you selected.

Holding the paper, imagine two things:

- 1st : You can see right through the paper.
- 2nd : You will draw the objects the size they are.

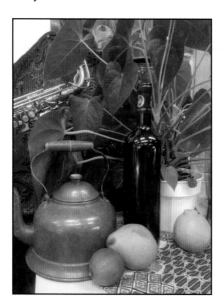

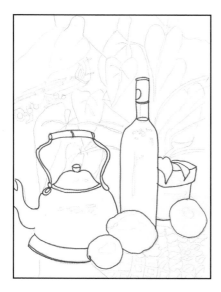

4. Draw objects in the foreground.

Note: Your foreground (in front) objects should not touch the bottom of the paper, allowing space for the table to be drawn later.

About 2-3 inches from the bottom of the paper, use your bold black marker to draw the outline/contour of the object closest to you.

Make the object large, even life-size.

5. Add other objects in the foreground.

Add the other objects that are next to one another in the foreground.

Draw every object, one at a time.

If an object is behind another, make sure to place it a little higher on the paper.

- Note the size of one object compared to another.
- Do you see where objects touch and overlap?

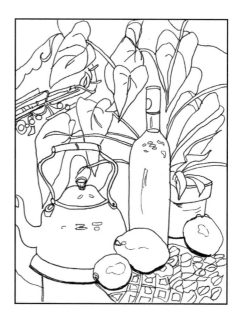

6. Draw the background.

- Draw a table or tablecloth under your objects.
- Add a fun pattern on the table cloth.

- Fill the entire paper with objects that are in the background.

Be sure you have lines touching and "bleeding off" all sides of the paper.

PREPARATION

Refer to *Essential Ingredient 6, The Values in Shading.*

7. Identifying the highlights:
 - The way and place that LIGHT hits an object creates a shadow and defines the object.
 - Where is the light coming from that is shining on your still life? Take some time to figure this out.
 - Focus in on one object, perhaps the one with the most reflective surface. Squint your eyes if needed.
 - Where is the brightest, lightest area of that object?
 - The brightest, lightest area is referred to as the HIGHLIGHT of that object.
8. Mark the highlights on your objects.

 Indicate where the Highlights are with marks from your black pen.

Your still life is now ready for color.

You will color each object.

You do not have to use the same colors as the objects really are.

Don't worry about the black marker lines. At the end, when your picture is totally colored, you will go over the outlines of your original drawing with the black oil pastel.

Using Oil Pastels

Do not use black oil pastel until the end.

Oil pastels are like coloring with lipstick. They smear and mix to produce wonderful effects.

Placing white on top of a color and blending it will create a tint of that color.

Using white for creating a tint is a great way to make a highlight.

You will cover the entire piece of construction paper with oil pastels.

Press heavily so the pastel is OPAQUE (you cannot see through it).

You will not be able to see what color your paper is. (However, know that by using colored paper you will add depth to the oil pastels you use.)

Don't hurry with the coloring of this still life. Take a break.

Complete it on another day or at another sitting.

9. Color every object, including all of the details.

 Add highlights where the light hits an object.

 Remember you can use white on top of a color to do this.
10. Once completed, use a black oil pastel to go over all of your original drawing lines.

Optional: Add a gloss protective coating.

You can cover your finished piece with semi-gloss or matt Liquitex® acrylic medium.

Use a sponge brush to lightly cover the oil pastel.

Do not rub hard with the sponge brush or your pastels will smear.

Let the acrylic medium dry overnight.

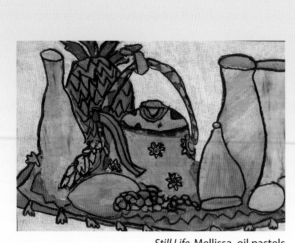
Still Life, Mellissa, oil pastels

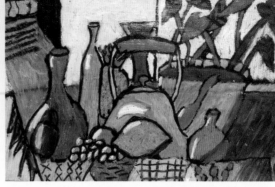
Still Life, Justin, oil pastels

REFLECTION ZONE

Do you do see where the light hits the objects in your still life?
Where was the light source? Where was the light coming from?
How did you feel while creating this still life? Would you be comfortable doing another sometime?

CLOWN FACE PROPORTIONS
OIL PASTELS

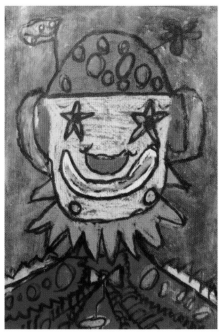

Clown Face, Justin, kindergarten, oil pastels

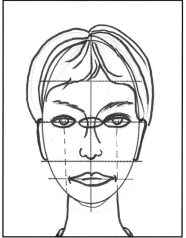

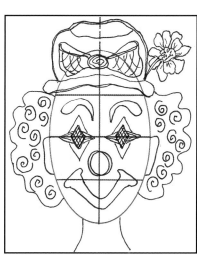

We all wear a mask. Our faces can express many different emotions. Sometimes we show we are happy. Other times we show we are sad.

Clowns paint their faces to exaggerate their expressions to make us laugh. Also, that way their faces can be seen from far away.

Background Knowledge

On the Internet find interesting photos of happy and sad clowns.

Print out one or more clown faces that fascinate you.

PREPARATION

Refer to *Essential Ingredient 8, The Face Recipe.*

Supplies:

- photos of clown faces
- 12" x 18" colored red or purple construction paper
- black thick marker
- oil pastels

1. Place your paper vertically. Draw with the black marker.

2. Touching the top of the paper, make a silly hat.

 Decorate your hat with patterns.

 Patterns are repeated shapes.

3. Make crazy clown hair.

 If you want, make the hair touch both sides of the paper.

4. Make a chin and neck.

5. Draw exaggerated eyebrows and eyes. (Are they stars?)

6. Draw the shape of the nose and a large mouth.

7. Add a neck. We look silly without necks!

8. Add the shoulders going off the sides of the paper.

9. Draw fun patterned clothing for your clown.

10. If you have a lot of empty background space behind your clown, make a pattern to fill it in.

 Your completed drawing is now like artwork in a coloring book, ready to be colored.

Using Oil Pastels

Oil pastels are like coloring with creamy colored lipstick. They smear and mix to produce wonderful effects.

Do not use black oil pastel until the end. We will use it, then, to detail the lines you have drawn.

Clowns often start by covering their face with white grease paint. Let's start there, too.

11. With a white oil pastel, "paint" the face.

 Oil pastels are OPAQUE (you cannot see through them).

 Press heavily with the white pastel so you cannot see the paper.

12. Color every shape in your drawing, one at a time.

 Have fun mixing oil pastel colors. Add white to make a color lighter.

 Color the entire background. Color until all of your construction paper is completely covered.

13. Use black pastel.

 Once no construction paper is showing, use black oil pastel to go over every black line you made with your marker. This will get all of your details back.

REFLECTION ZONE

Why does your clown look happy or sad?
Did you create different patterns in your clown's clothing?
Did you like using oil pastels? Did you mix any oil pastels to make new colors?

ACTIVITY 26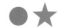

FISH BOWL
CONTOUR DRAWING AND WATERCOLOR

Henri Matisse, *Goldfish,* 1912
Photo: Archives Henri Matisse, all rights reserved.
Artwork: © 2019 Succession H. Matisse / Artists Rights Society (ARS), New York.

Note: *This lesson is for artists age 5-10.* More mature artists may enjoy the Alternative Activity at the end of this lesson.

Henri Matisse was 43 when he painted this picture called Goldfish. I like the way you can see the fish from the top.

In many cultures, goldfish are symbols of wealth and good fortune. Folklore tells us that the goldfish have magical powers if you make three wishes.

Henri Matisse enjoyed using goldfish as subjects. He painted them in at least 10 of his paintings. Matisse was mesmerized and calmed while watching fish.

When he watched them, it was similar to a meditation exercise.

We can call this "Matisse MINDFULNESS."

Supplies:

- a live gold fish or a variety of fish, and/or fish photos
- 12" x 18" or 11" x 15" watercolor paper
- **permanent** black marker
- camel hair watercolor brush, size #10
- 16 pan watercolor set
- art tape to tape watercolor paper
- water

Fish Bowl, Christopher, age 5, watercolor

This was my 1st lesson with kindergarten artists. Thank you Janet Logan, my mentor art teacher. When I first came to Irvine, I used her phrase, which I already believed:

"There are no mistakes in art."

Place watercolor paper horizontally on a table. Option: Tape edges down to hold in place.

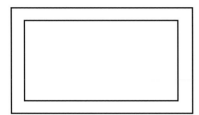

WARM UP

Look at the fish. If you have a real fish, point at the fish with your finger in the air and slowly draw the outside line of the fish. *Artists have to be very quiet so they can turn their art brains on and really see.*

If you have a photo of a big fish, start with your finger touching its mouth. **SLOWLY**, trace around the upper fin. It is like going up a mountain. Next touching the paper, draw around the very large tail that helps your fish swim. Continue with your finger touching the picture of a fish until you finish the entire outside line. The is called the **CONTOUR LINE**.

Reminder: Fish do not have any straight lines because they are organic/alive.

That was so easy! Now **with your finger (no markers yet)**, draw that same outside line of your fish on your paper. Take your time.

1. Draw your fish larger than life. Decide where you will start before you pick-up your black marker.

 Slowly draw the outside line. There are no mistakes, so if you make an extra bump, just make it into something. Keep looking at your real fish or the photo to finish the outside line.

1.

2.

2. Draw every single line you see. Draw his eye. How does the fish breathe? He has gills. It almost looks like he is smiling.

 How many lines are in the fins and tail? They are not straight, are they?

3. If you could pet the fish, would he be smooth? Does he have scales all over his body? Draw them. They make a PATTERN. A pattern is a repeated shape. The fish has TEXTURE. Texture is the way something feels, like rough or smooth.

4. Put your fish in a fun container. Put a long Oval at the top if you want to see in. The fish container can be symmetrical (the same on both sides), OR Invent a crazy fun bowl.

If you want a challenge, make a few fish to fill the entire page. You will not need to create a fishbowl.

5. Create a HABITAT. What is your habitat? Where do you live? What are your surroundings? Create an environment for your fish.

Note: Does your habitat go in front or in back of your fish?

Sometimes you may have to "JUMP OVER" your fish to make it look like the growing plants are in the **background**.

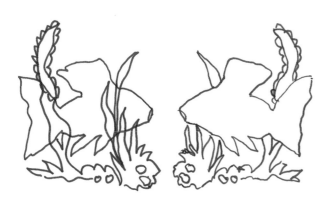

Also, remember what is in front is called the **foreground.**

PREPARATION
Review *Essential Ingredient 3, Watercolor Techniques.*

6. With a brush, put a WASH of water on the paper in only the Negative space. This is the back-background, behind the fish and your habitat drawing. It is the water the fish lives in.

Since your watercolors each have a drop of water in them according to watercolor techniques preparation, choose 2-3 colors close to each other on the color wheel (analogous). Cool colors like blues, blue greens and purples work well. Paint only the background. Place wet color next to wet colors and they will blend. This is called "wet into wet". If you have a pool of water, you may gently hold a tissue to pull up unwanted water.

Take a break. Let your background dry.

7. Think of all of the beautifully colored fish you could see if you could go snorkeling in the ocean. Although we started with Goldfish, you have artistic privilege to paint your fish with new colors.

Paint your fish. Remember, if you don't want colors to mix, allow an area of the fish to dry before painting next to it.

Be sure you continue to clean and dry your brush in between changing colors.

8. Paint your habitat. Don't lift your paper until your art is dry. If you have art tape, carefully pull tape off to create a frame.

Alternative Activity
For 10-year-olds and beyond

1. Instead of using watercolor, with a permanent pen, fill your entire paper with a variety of fish and the habitat.

2. Tear very small pieces of colored tissue paper.

3. Apply tissue after brushing a section of your drawing with liquid starch.

4. Brush starch on top of tissue to hold tissue paper in place. If you don't have starch, mix white glue with water (½ and ½).

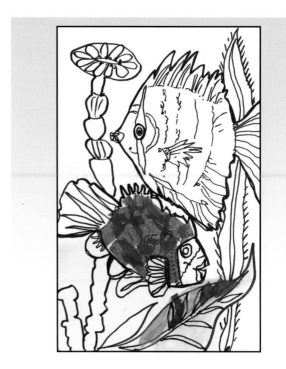

REFLECTION ZONE

Tell one another what background and foreground mean.

Point out the objects in the foreground.

Would you like to make a picture of yourself in your habitat? What is your habitat?

What colors did you use in the background in your wet-into-wet wash?
Did the colors run together?

ACTIVITY 27

MONSTER INSECTS
CUT PAPER

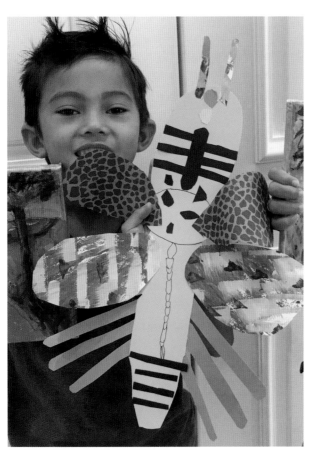

My Monster Insect, MB, age 5, cut paper

Entomology is the study of insects.
The word *"entomon"* means insect in Greek.

Insects have:

- a head
- thorax (upper body)
- abdomen (stomach)
- 2 antennae
- 6 legs (three pairs of walking legs)
- usually a pair of wings

Supplies:

- pictures of insects
- assorted colored construction paper
- additional patterned papers
- optional: paint some fun textured papers
- scissors
- glue sticks
- thick and thin black water base makers
- 12" x 18" black or colored paper to glue insect onto when complete

Background Knowledge

On the Internet, search insect pictures.

Printout one or more insects that you like.

PREPARATION

Refer to *Essential Ingredient 10, Drawing With Your Scissors.*

Optional Advance Preparation:

Look up Eric Carle and his paper making.

He made his own paper to create wonderful illustrations in his books, including *The Very Hungry Caterpillar.*

He "drew with his scissors" to cut the many shapes he used.

Making your Own Paper

Using tempera paint on white paper, create fun paper to use when you make your monster insects.

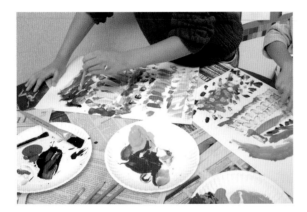

Making your Monster Insect

Use a variety of papers to cut the following shapes.

You will not need a pencil, because you will be drawing with your scissors.

1. **The Head**

 According to the directions illustrated in *Drawing with your Scissors*, make a circle by rounding the sides of a square piece of paper.

 (Paper size approximately 2" x 2")

2. **Upper Body**

 Create the upper body by rounding and cutting the edges off an elongated rectangle.

 (Paper size approximately 2" x 3")

3. **The Stomach**

 Cut another long oval for the stomach by cutting off the sides of a long rectangle.

 (Paper size approximately 3" x 3")

4. **Connect the Head, Upper Body and Stomach**

 With a glue stick, connect the head and body pieces together.

 Only put glue where the pieces of the body connect to one another.

 (Do not put glue on the entire cut piece of paper.)

5. **Antennae**

 Draw with your scissors to cut 2 antennae shapes.

 Any time you want to make two of the same shapes, fold the paper so you can cut two at a time.

 Glue the antennae to the back of the head.

6. **Wings**

 Fold paper to make 2 or even 4 larger rectangles (depending on how many wings you want).

 Then cut the corners off to make oval shapes to create your wings.

 (Paper size approximately 3" x 6" for each pair)

 Glue your wings onto the insect body.

7. **Legs**

 If you see them in the picture you printed, cut out shapes for 6 legs.

 Glue the legs behind the body or wings.

8. **Continue cutting and gluing detail shapes to make your insect better and better.**

9. **Adding More Details**

 With your thick and thin water based black pens, draw lines to add details to your insect.

You may display all of your insects on a wall, so they are flying.

Or glue them to a piece of background paper.

REFLECTION ZONE

Do you believe you can cut any shape by drawing it with your scissors?
Tell about the body parts of your invented monster insect. What can it do?
Do you have any books by Eric Carle? Did you look at any of his illustrations that he made with cut paper?

ACTIVITY 28

BODY PROPORTION SELF-PORTRAIT
TEMPERA PAINT

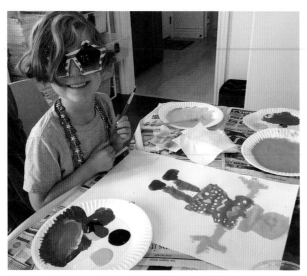

Self Portrait, "G," age 5, tempera

Supplies:

- white 12" x 18" paper placed vertically
- plate with the primary colors: red, blue, and yellow
- plate with 3 squirts of white and one squirt of black
- brush: camel hair round, size #8 or #10
- Q-tips® for facial details
- newspaper and lots of paper towels
- water

PREPARATION

Refer to *Essential Ingredient 7, The Body Recipe.*

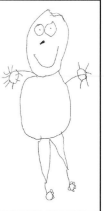

Remember when you were young and drew the head really big? When you added the body, it looked small *compared to* the head. Just by looking at the drawing, here, we know that the head is not in **proportion** to the body. (And the arms are too short!)

In this activity, you will paint a self-portrait of your body with all the parts in correct proportion. Don't worry if you're wondering, "How will I do that?"

The Body Recipe makes it easy. It gives you a simple way to know in advance—before you draw—how large or small the arms, legs and other parts usually are compared to each other.

Take some time to get to know *The Body Recipe*. Depending on your age, for example, you are about 5-7 heads tall. Your arms are 3 ½ heads long. Following *The Body Recipe*, you will easily paint your body self-portrait in proportion.

1. **Make your skin tone color paint.**

 For **light skin**:
 - Start with one of the squirts of white paint on your plate.
 - Add yellow and a dot of red.
 - Adjust accordingly, for your own coloring.

 For **dark skin**:
 - Mix the 3 primary colors to make brown.
 - If you want your skin a lighter brown, add a little more yellow.
 - If you want your skin darker, add more blue.

Be sure you make enough skin color to use for your arms and legs later.

2. **Paint the head.**

Using your skin tone paint the oval shape of your head, touching the top of the paper.

3. **Paint your neck and ears** with skin tone color.

We will be painting the hair, eyes, mouth and nose later, after the head dries.

Note: Anytime you create a new color, take time to clean and totally dry your paint brush with paper towels.

Don't smash the brush.

With the paper towel, bristle up, dry and make it into a point.

PREPARATION

Refer to *Essential Ingredient 2, Creating New Colors with Paint.*

A self-portrait is a picture of yourself.

When painting your body self-portrait, put yourself in either the actual clothing you are wearing or, if you have a favorite outfit, you can paint yourself in that outfit instead of the one you are wearing.

4. **Paint your shirt and pants, or dress.**

 Mix your new colors as you need them.

 Each will be a new batch of color on your plate.

5. **Paint your arms and legs.**

 Decide: Will you show yourself standing or "in action"?

 If you want to be dancing, ask yourself, "What do my legs do when I'm dancing?" For example, one knee can be bent.

 What music are you listening to?

 How would you move your arms to your favorite song?

 Use the remaining skin tone color to paint your arms.

 Paint the part of the legs that show.

6. **Paint your hands and feet.**

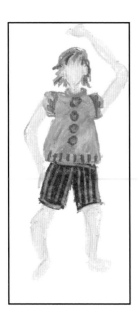

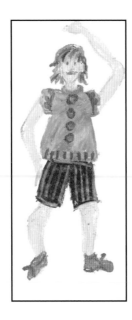

7. **Paint the details on your clothing.**

8. **Add your hair.**

 To make brown, mix the 3 primary colors. If you have blonde hair, add more yellow.

9. **Put some shoes on your feet.**

10. **Make your eyes, mouth and nose** using a Q-tip®.

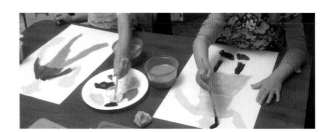

REFLECTION ZONE

Did you make the color of your favorite outfit or the clothes you are wearing?
What colors did you mix to make the color of your clothes?

Is your body in proportion?
How many heads tall is it?

What action are you doing in your self-portrait?

ACTIVITY 29

BUTTERFLIES
WATERCOLOR

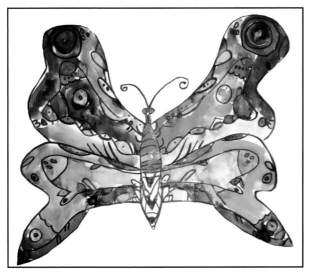

Butterfly, Justin, watercolor

Butterflies and moths are members of the second largest group of insects in the world. Scientists call this group Lepidoptera. They made that name from two ancient Greek words (*lepis* = scale and *pteron* = wing).

Nearly all baby moths and butterflies start out as caterpillars! I like caterpillars. Why didn't the scientists also include a word for them? I don't know. That's a good question!

Background Knowledge

On the Internet, find detailed butterfly images. Print out your favorite butterflies.

Did you know?

> *Mariposa* means butterfly in Spanish.
>
> *Papillon* means butterfly in French.

Discussion Topics

What is symmetry?
> Equal balance on both sides.

The life cycle of a butterfly is:
1. egg
2. caterpillar (larva)
3. cocoon (chrysalis)
4. adult butterfly

Supplies:

- thin black permanent pen
- detailed photos of butterflies
- watercolor set
- #10 round camel hair paint brush
- 12" x 18" watercolor paper
- Kleenex
- scissors and glue
- background paper to glue finished butterfly onto
- water
- optional: glitter glue

1. Place your watercolor paper horizontally.

 Point with your finger to the center of the paper.

 This is where the body of the butterfly will be.

2. Draw the body.

 Looking at your butterfly images, use the thin permanent pen to:

 - Draw a shape for the **head** of the butterfly.
 - Draw the long **body**.
 - Draw detail lines of the body.
 - Add 2 **antennae** to the top of the head.

3. Draw the 2 top wings.

 Warm Up: Contour drawing with your finger.

 Contour drawing with your finger is a technique where, instead of a pen or pencil, you use your "pointer finger" to draw the outline of what you are about to paint, in this case, a butterfly. Here's how to do it.

 - Choose the butterfly photo that you want to paint.
 - Place the photo next to your watercolor paper.
 - On the photo, with your "pointer finger," slowly draw/trace the outside contour line of top butterfly wings.

Now, with your pen, draw the outside line of the two top wings.

Note: Your wing outlines do not have to be perfectly symmetrical. *This is a free-hand drawing.*

4. Draw the 2 lower wings.

 Warm Up: Contour drawing with your finger.

 As before, but now for the lower wings.

 - On the photo, slowly draw/trace the outline of both lower wings with your pointer finger.

 With your pen, draw the outline of the two lower wings.

5. Draw the patterns (repeated shapes) that you see in the top wings.

 If you draw a shape or line on one wing, do the same shape on the opposite wing.

 This will make your butterfly balanced, or what is called, **symmetrical**.

6. Draw the patterns and lines in the bottom wings.

7. Darken in some smaller shapes with black.

8. Make some of your lines bold/thicker.

PREPARATION

Refer to *Essential Ingredient 3, Watercolor Techniques.*

9. Paint your butterfly.

 - Follow the watercolor technique instructions to carefully paint your butterfly.

 - Your colors do not have to match those in your butterfly photo.

 Tip: With watercolors, you can always make the color more intense by adding more of the same color paint. First apply your watercolor with a light, transparent amount of color on your brush.

 If needed, apply more of the same color to darken and add intensity to your color.

 Reminder: If you place a color next to another color while it is WET, the two colors will mix. This could be a good thing or a bad thing!

 Tip: You may use Kleenex to pull up excess water. Don't blot.

10. Allow your piece to dry.

 Optional: Add glitter glue.

 Once your butterfly painting is dry, you may carefully draw over some of your lines with glitter glue.

11. When it is completely dry, cut out your butterfly and glue it to a piece of background paper.

Butterfly, watercolor

REFLECTION ZONE

What does symmetrical mean?
What was your favorite part of creating your butterfly?
What are the life cycle stages of butterflies?
How amazing is it that a caterpillar can turn into a butterfly?

RE-INVENT THE SUN
OIL PASTELS

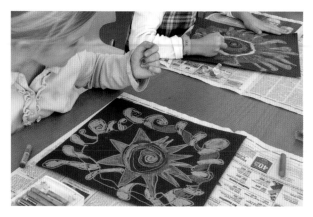

Fun Facts About the Sun

The sun is a star, the closest star to our planet.

The sun's light reaches the earth in eight minutes.

The sun is very old, over 4.5 billion years old.

Without the warmth of the sun, the earth would be frozen. No one could live here!

We cannot safely look at the sun but, we may have a vision of what it looks like.

PREPARATION

Adults will want to read **Chapter 2, The Universal Language of Symbols** in preparation for sharing this lesson with younger children.

Background Knowledge

- Patterns are repeated shapes.
- Shapes are a closed line.
- Shapes can be ORGANIC, life-like, or GEOMETRIC, like triangles, circles, and squares.

Reinventing the Sun

1. Test your gold pen. Shake it with the top on. Then draw on a piece of newspaper to check that it's working. Do this each time, before you use it.

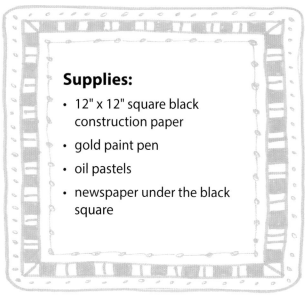

Supplies:

- 12" x 12" square black construction paper
- gold paint pen
- oil pastels
- newspaper under the black square

2. Draw a small **circular shape** where you want the center of your sun.

 It does not have to be in the center of your square.

3. Draw designs and **rays** radiating out from that center, like the solar fire that shoots out from the sun to warm us.

 Add patterns and details.

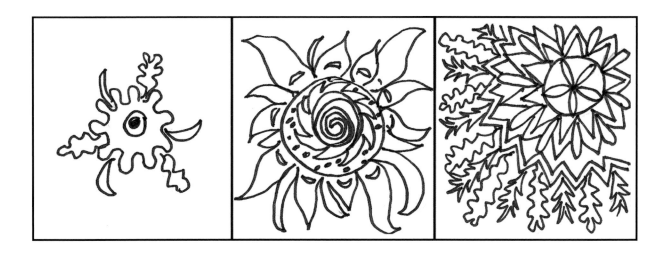

4. Be sure the gold lines and shapes are almost touching all 4 sides of the square black paper.

 If you get a "blob" of gold paint with the gold pen, don't be concerned. Think of it as part of the sun.

Using Oil Pastels

Oil pastels are like coloring with creamy colored lipstick. They smear and mix to produce wonderful effects.

5. Carefully color in each of your **SHAPES with the oil pastels.**

 Press hard with the oil pastels so you will barely see the black paper.

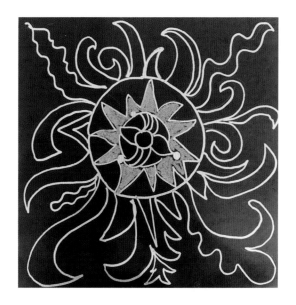

REFLECTION ZONE

Does the sun look like this?
Congratulations! You have now created a much more exciting sun.
What else do you know about the sun?

BIRDS OF PARADISE
WATERCOLOR

Bird of Paradise, Ian Proehl, 1st grade

These flowers remind us of colored birds in flight with their beaks and plumage like crowns. Originally from South Africa, they are also known as Crane flowers.

PREPARATION

Refer to *Essential Ingredient 3, Watercolor Techniques.*

Set Up

1. Place your watercolor paper vertically (short side up).

 Tape both sides down, from top to bottom, covering about ½" to ¾" on each side of the paper. This holds the paper in place during the painting process.

Warm Up

2. It is helpful to actually place a flower on the paper to see the actual size of what you are about to draw.

 Then place it back in the vase.

 Look carefully at it. (Do not trace the flower.)

Drawing

3. Using permanent black pen, draw the CONTOUR (outside line) of one flower.

 Make it life-size.

4. Add the shape of the strong stem and take it right off the bottom of the paper.

 The stem is not one thin line.

Supplies:

- Bird of Paradise flower with a leaf in a tall vase
- rectangular watercolor paper 8" x 18" or 9" x 24"
- masking tape or art tape
- permanent black marker
- crayons for resist
- watercolor paints (16 pan semi-moist)
- #10 camel round watercolor brush
- Kleenex®
- water

5. Behind the first flower, draw a large leaf. Your flower is in front, so you do not see all of the leaf.

 The flower covers or overlaps the leaf.

 Looking closely at the lines in the leaf, what do you see?

 Examples:

 - No line is straight.
 - The lines are **organic** (life-like).
 - Draw every line in that leaf.

6. If you have room, add another flower.

 Consider:

 - Which direction do you want the "beak" to point?
 - Will you see all of the flower or is part of it behind the leaf or another flower?

 You may add additional leaves in back.

7. Do not draw the vase.

 It is there just to hold your flowers in a still upright position for viewing.

Add Crayon

8. Do not color in a shape.

 Color some lines and textures with crayons.

 For example, use your crayons to make yellow-green lines in the leaves and some orange or deep purple where you see it in the flower. Press heavily on the crayons while drawing with them.

 Why do you want to heavily apply the crayons?

 That way, when you paint over them, the crayon's wax will **resist** the paint (won't let the paint through).

Painting

Follow the watercolor technique instructions in *Essential Ingredient 3, Watercolor Techniques*.

Tip: With watercolors, you can always make the color more intense by adding more of the same paint. So, first paint with a light amount of color on your brush. If needed, apply more of the same color to darken it.

9. Wet your paints with a dot of clear water in each color pan to soften the paints.

10. Brush clear water in the **negative space** first.

 Negative space is the "nothing space" or air in the background.

11. Use one color to paint only the negative space around the objects.

12. Allow the background to dry.

13. Paint the flowers one at a time.

 - Note that the paint won't stick to wherever you placed crayon. Good.

 - Remember, if you place wet paint next to wet paint, is will run together.

 - Remember to only let the color touch the tip of the brush.

 - If you get a large pool of color, gently touch a tissue to it to "pull" some of that water off the paper.

14. Once the painting is complete and dry, gently remove the tape from both sides. That will make a "frame" for your piece.

Optional Activity:

It would be fun to paint a large Bird of Paradise among its leaves, using tempera or acrylic on canvas.

Paint a colorful background.

Bird of Paradise, acrylic

REFLECTION ZONE

How successful did you feel drawing your first Bird of Paradise flower?
What would you do differently next time?

If in a group, put everyone's paintings next to one another to create a garden of color.

Discuss:
What do you like in your own piece? What do you like in the other paintings?
How do they all look together?

How many flowers did you put in your painting?
How many leaves?
Point out where flowers overlap leaves.

WATER LILIES
CLAUDE MONET
TEMPERA PAINT

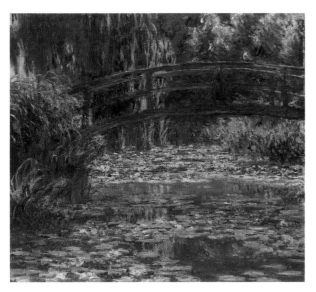

Claude Monet, *Water Lily Pond,* 1900
Courtesy of The Art Institute of Chicago.
Mr. & Mr. Lewis Larned Coburn Memorial Collection.

Supplies:
- 8" x 18" Bristol board white paper
- box of Q-tips®, no brushes
- tempera paint: palette/plate with warm colors: magenta, yellow, red, orange
- tempera paint: palette/plate with cool colors: purple, greens, blues
- pencil or black crayon, no eraser
- optional: gloss medium and sponge
- brush for protective coating

Claude Monet was fabulously defiant. He questioned traditional academic art and is considered the father of Impressionism.

In 1845, when Monet was 5, his family moved from Paris to Le Havre, a port city in the north of France. Monet did not do well in school but loved to draw. When distracted, he often drew humorous caricatures of people, which he sold for a few francs. I would have loved to have him as a student.

Monet's only interest was to be an artist. His father disapproved; he expected Claude to eventually work in the family business. At 20, Monet was drafted into the French army and served in Algeria for a year. Afterwards Monet returned to Paris to pursue his dreams.

There Monet found his "tribe" while working with artists Pierre-Auguste Renoir, Frédéric Bazille, and Alfred Sisley. Together they painted outside, "en plein air," captivated by light and capturing the moment. Colors were applied quickly with one brush stroke next to the other.

Rejected by the Paris art establishment, Monet and his colleagues organized their own exhibition in 1874. There, Monet debuted his work, *Impression Sunrise*, the painting that inspired the name of the new movement.

Monet painted outside, rain, shine, or snow so he could capture the light and shadows at different times of day. He loved water and even painted on a boat he called his "floating studio."

At age 43, Monet moved to Giverny, 50 miles outside of Paris, where he purchased a house and property that eventually included lily ponds. From 1899 until his death in 1926, he painted a series of over 250 paintings of water lilies, often including the Japanese bridge that crossed his pond.

During this time Monet's eyesight began to deteriorate. As an artist, I cannot imagine how disturbing this must have been for Monet. He could not see colors with the same intensity, and his work reflected this.

His later water lily paintings are notable for their absence of detail and less recognizable forms. This gave his work a whole new dimension with an abstract style that links Impressionism to the beginnings of modern abstract art.

Monet's water lily paintings have a wonderfully loose and fresh feeling. They are treasured to this day.

Water Lily Pond, Miranda Burgett, 2nd grade, tempera paint

Background Knowledge

On the internet search: Monet Japanese bridge images.

Print out ones that include the water lily pond.

Here is a photo I took of the Japanese foot bridge at Giverny.

This is the water lily pond below the bridge.

You will be creating a painting of Monet's water lily pond, modeling his loose, fresh style.

Warm Up

First, take some time to relax. You can imagine you are at Giverny. Just know you are there, at the water lily pond. The Japanese bridge is there. Monet is there, and you are watching him apply color to canvas, quickly, one brush stroke next to the other.

Making a Pencil Sketch

Looking from a printout of the pond and Japanese bridge to your bristol board paper, you will block-in the areas that you will paint later. This is a fast "5-minute" sketch.

1. Place your paper horizontally (long side up).

2. Pencil sketch the arch of the Japanese bridge across the top of your paper.

 It does not need to be in the center. In fact, it will be more interesting if it is not symmetrical.

 Make three arches, one for the bridge and two for the handrails.

 Add the remaining vertical lines of the bridge.

3. Softly indicate where the lily pads are under the bridge.

4. Draw the lily pads. The closest are lower and larger on the paper.

 The ones farther away are smaller and higher on the paper.

Painting

Use your Q-tips®, one for each new color you apply.

Mix the colors on your palette.

Apply paint in the following order:

5. The **Japanese bridge**.

 The bridge is turquoise, maybe with a touch of green.

6. The **lily pads** with **colorful flowers**.

 Use Yellow-Greens for the lily pads and bright warm colors for the lily flowers.

7. What time of day is it?

 The **sky** can be warm colors—magenta, yellow, orange, and/or red.

 Mix your colors with Q-tips® right on the paper.

 Or, if it's later in the day, the sky can be turquoise or other colors such as purples and blues mixed together right on the surface of your piece.

8. Paint the **wild plants** on the sides of the pond.

 Use cool greens for the textured **wild plants** on the sides of the pond.

Be sure to include the plants you see under the bridge that are on the side of the pond.

9. Paint the **water** between the water lilies.

10. Cover every part of your paper with paint.

 Create textures with your Q-tips®.

Optional: Add a gloss protective coating.

You can cover your finished piece with semi-gloss or matte Liquitex® acrylic medium.

Use a sponge brush to **lightly** cover the tempera.

Let the acrylic medium dry overnight.

Water Lily Pond, tempera paint

REFLECTION ZONE

Did you allow yourself the freedom to "loosen-up" before and during this activity? Did you find that helpful?
What do you like about your piece? Why?
What do you find interesting about Claude Monet?

CHAPTER 6

WELCOME MODERN-DAY RENAISSANCE MEN AND WOMEN
Seeking a Broad Array of Skills and Knowledge

It is time you gathered with others in forums to socialize, draw and paint. Experiment using the **Recipes for Success** experiences in this book.

My challenge to you:

Commit to make an appointment to nourish yourself with the wordless language of art.

Become a Renaissance Man or Woman!

The Foursights, Corinne

Consider the following reasons to support your commitment.

Choose one or more that are the most meaningful to you:

☐ You want to have an interest in lifelong learning, while adding skill sets and pursuing interests.

☐ You are interested because you are multi-talented.

☐ You have a curiosity about Art and desire a happy, challenged brain.

☐ You want to or do appreciate creative expression.

☐ You want to make aesthetic judgments and be perceptually aware.

☐ You have a desire and the time for making art.

☐ You have missed this child-like wonder of making art that wasn't fully nourished in your elementary days.

☐ You seek Global Knowledge and want to use all the capacity of your mind. What a world we live in!

☐ You have free will to be the author of your lust for continuing your liberal arts education.

☐ You have an open attitude and internal passion that allows you to grow with new purpose.

☐ You are intrigued to develop your own style, while savoring greatly needed creative expression.

CHAPTER 7

MINDFULNESS, MEDITATION & ART

Experiencing art is meditative. It is a non-temporal. It is therapeutic. Throughout the ages, art has gifted us spiritually while inspiring ineffable knowledge. Making art brings a wonderful sense of well-being. Exercise physically activates endorphins that reduce stress and make us feel great. Creating art produces a similar natural high. The mind calms and, at times, a sense of adventure draws us into the moment. That is the essence of this book. It's really about that experience, what I call the **"Pizazz of the Heart."**

What is meditation? We can think beyond a particular breathing or mindfulness practice. While there are many meditation techniques, they all fall within the following general definition.

Meditation is:

Any mental or physical activity that promotes happiness and peace of mind.

From walking on the beach to fixing up an antique car, we all have favorite activities that promote health and inner peace.

What is mediation for you? Is it yoga? Do you have a mantra? Is it golf? Or biking? Do you "chill-out" to music?

If you are already an artist, hopefully this book will deepen the sense of joy you get from creating. If you are new to art, I invite you to experience the process, and add it to the meditative activities that you currently enjoy.

There's so much stress in our lives. How often do we get a distracted? How can we deal with all the emergencies and problems of the earth? It's too much responsibility.

Dreams do come true. We recently went to Tahiti. What a paradise! The first morning, at breakfast, my husband said, "See that family on their cellphones?" He nodded towards a table below us where, sure enough, all five sat consumed by their phones. We were stunned.

Why had they come to Tahiti? To relax? Where will they find their tranquility if they can't find it in paradise?

Centering, Corinne, Aqua Tint Series, 1978

I did this etching at a time of change. I was surprised at the calm it brought me.

I found myself repeatedly going back to the concept of centering. I dreamed I was stepping on stones and water to the center of the earth, to my center, to my future.

Re-centering works. To this day the piece reminds me of that space in time, before moving forward.

Meditation calms the "chatter of the mind." It is too easy to get stuck in our heads. Ruminating about something can conjure up stories that worry us even more. Our need to re-center and find balance is ongoing. Mindfulness teaches that overzealous worrying naturally dissipates as we live more in the present moment. Be in the present; Let your worries go.

While I don't have a formal meditation practice, I am often inspired by the words of those who do. Sometimes I write down an inspiring quote, as I did with Jon Kabab-Zinn's definition of mindfulness.

Making art frees me. When I'm drawing or painting, it's as if my mind releases endorphins, calming my thoughts and energizing my focus. Such feelings come fairly quickly and naturally in our creative, right brain state. I invite you to experience something similar.

Enough said. Let's DO art. Leave the chatter of our mind, and jump into the **Pizazz of the Heart.**

Thanks to Jon Kabat-Zin, one of my "centering cards" says:

"To pay attention, on purpose, in the present moment, as if your life depended on it, non-judgmentally."

ACTIVITY:
Creating a Mini Portfolio of Inspirational Visuals and Words

Creating Your Portfolio

1. Create and glue meaningful "treasures" on two 5" x 7" white canvas boards. "Treasures" are objects that tell something about you.

PREPARATION

Refer to *Essential Ingredient 2, Creating New Colors With Paint.*

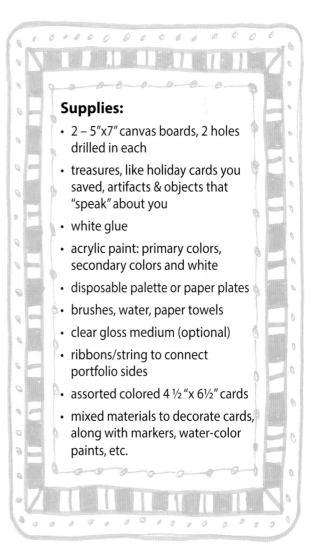

Supplies:

- 2 – 5"x7" canvas boards, 2 holes drilled in each
- treasures, like holiday cards you saved, artifacts & objects that "speak" about you
- white glue
- acrylic paint: primary colors, secondary colors and white
- disposable palette or paper plates
- brushes, water, paper towels
- clear gloss medium (optional)
- ribbons/string to connect portfolio sides
- assorted colored 4 ½"x 6½" cards
- mixed materials to decorate cards, along with markers, water-color paints, etc.

2. Lay both 5" x 7" canvas boards next to one another. Paint with acrylic paints. Let them dry.

 Optional: Cover with clear (Liquitex) gloss medium to protect. Let dry.

3. Tie the two canvas pieces together with ribbons or string.

Your portfolio is ready to fill with insights!

Find 1 or More Words or Quotes

 ... that speak to you.

Creating Your Cards

Open to possibility ...

1. On a 4 ½ x 6 ½ card, write down or script your words or quote.

2. Using paint, markers, watercolor, glue, cut papers, et al, design and create a collage for your words. Let dry.

3. Place the card(s) in your mini portfolio for future reference.

Add a card anytime, as often as you wish.

partial lotus, glued & painted over

hummingbird, cut from Papyrus card, painted over, with glued beads

Fleur de Lis (because I have some French in me)

Go to your portfolio for emotional calm and well-being. This is a present to yourself!

HAVE AN ART PARTY

Art Parties bring people together to create art. Art activities provide opportunities for socialization and conversation with loads of benefits:

- It's exciting to be around a group of artists.
- Your free, creative spirit comes to the surface.
- Your expressive passion and zest come out to play.
- Soul and intellect come together.
- The creative and intellectual sides of the brain merge.

Welcome Artists!

Types of Gatherings

Children with Parents

Share a fun, enriching experience with the family while doing one of the time-tested, interactive lessons in *Art For All Ages*. The occasion could be a celebration party on the weekend or an after-school event.

Consider sharing and discussing ***Chapter 2, The Universal Language of Symbols.***

Grandparents with Children

Jump into an experience with a young child and see the pure joy they experience making art. Experience the wisdom of the child within you that is waiting to re-surface.

You might go over one of the Self-discovery pieces in this book, such as ***Chapter 1, Where are You on the Artistic Scale?***

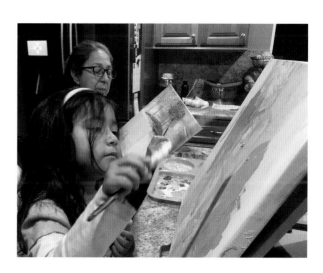

Three Generations

Embark on a multi-generational journey. What a wonderful way to create special memories together.

Read an inspiring piece beforehand, such as **Chapter 3, Brain Facts and Your Innate Creativity.**

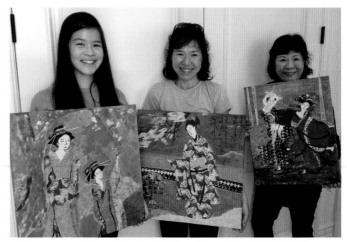

Ladies with Ladies

Gather weekly or monthly at one another's homes. The hostess decides on the lesson and has supplies ready. Consider sending guests a copy of **Chapter 7, Mindfulness, Meditation and Art** in advance of the event.

Three generations showing their collages from *Activity 4, Asian Figure, Collage.*

Adult Friends Together

Through fun, directed activities, participants release creativity and their artistic abilities. A unifying spirit occurs when socializing and making art together.

Your friends may want to consider reading **Chapter 9, Self-Discovery, Who are You?** before or after the event.

Note: Wine Art Classes are all the rage for men and women of all ages these days.

Preparing for Your Art Party

- Select a lesson from the **Recipes For Success.** Try the activity yourself in advance. That will help you gauge the appropriateness and the time allotment needed for completion.

- Print out a copy of the lesson, materials, and **Essential Ingredient** for each guest.

- How much time do you have? Younger children need no more than an hour. Adults can handle two hours or more. Longer activities may turn into two or three parties.

- Set up tables in advance, protected by paper or plastic.

- Have each work space organized with the supplies.

- You may want to include a supply list depending on your guests.

- At the event you can demonstrate step-by-step or take turns in the creative process.

Create Your Invitation

Here are some borders you can scan or photocopy and use to create your invitation.

Send out this Invitation

Invite your friends to an Art Party.

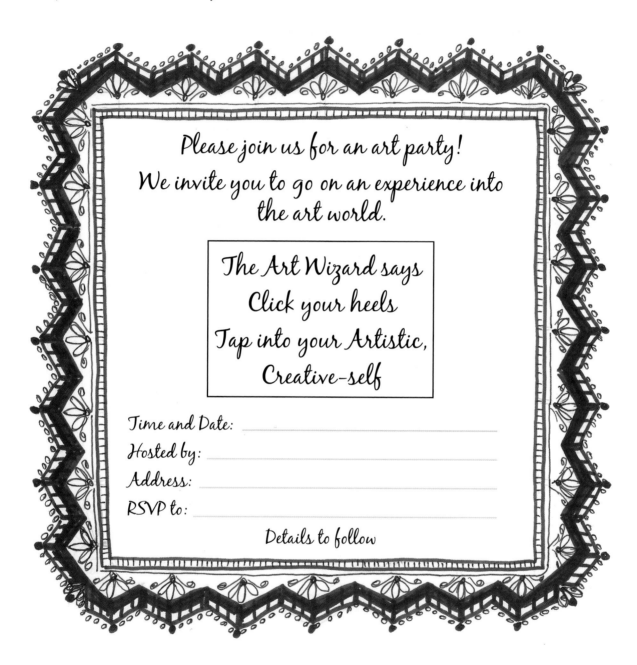

Please join us for an art party!
We invite you to go on an experience into the art world.

The Art Wizard says
Click your heels
Tap into your Artistic,
Creative-self

Time and Date: _____
Hosted by: _____
Address: _____
RSVP to: _____

Details to follow

CHAPTER 9

SELF-DISCOVERY
Who are you? Who do you want to be?

"Curiosity about life in all of its aspects is still the secret of great creative people."

Leo Burnett, Founder, The Leo Burnett Advertising Company

This chapter is for all of us who got the idea in art class or elsewhere that we're not creative, that we simply "can't do art." More generally, I hope what you learn below serves to reduce any limiting ideas you may have of your capabilities and potential.

We are born with a wonder and curiosity that sparks learning and development. We all share a similar start. By now you know yourself. Along the way you found your strengths and learned about or at least heard of your imperfections. If it was a difficult, bumpy process, you are not alone.

Negative messages we took on board then may still limit us now. Which of your skills and smarts were not acknowledged at school or afterwards? What if they had been?

I grew up in an "IQ world" that valued intellectual intelligence above all. Some of us were rewarded and others not so much. The SAT's and other college admissions tests reflected that bias, as did hiring practices.

The world is a very different place now. The IQ test, as you'll see, below, is no longer considered the pre-eminent or primary measure of intelligence. In the meantime, some of our other capabilities have been acknowledged and researched. Emotional Intelligence (EQ) and Creative Intelligence (CQ) are two such examples.

It's time to take a fresh look at ourselves and embrace our strengths. To help us make a proper inventory, let's take a look at our varied intelligences (IQ, CQ, EQ) and how we learn. We'll even take a brief personality test. Bringing your creative self to the forefront will alter your perspective.

How do you want to grow? How do you want to become more interesting, or more interested? Let's use our findings to answer those questions, to nurture ourselves and ignite our internal spirit. Let us embark on a journey of self-discovery.

Beyond the IQ Test

Roger Sperry's right-brain/left-brain studies of the 1960s set off a chain reaction amongst educators eager to explore their broader significance. This spawned a revolution in how we define and measure intelligence, with profound implications for how we see ourselves and our world. As a result, the IQ test, once considered the ultimate measure of intelligence, has been dethroned.

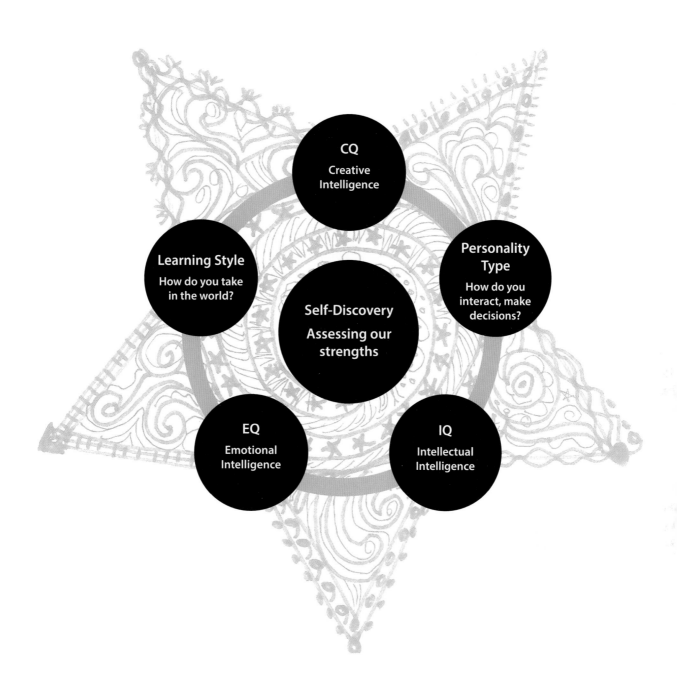

Who we are is a combination of the above factors.

**They all play a significant role in who you want to be and who you will become.
Be all that you can be!**

Many educators see the IQ test as a woefully inadequate benchmark of intelligence.

The IQ test primarily measures verbal and logical/mathematical intelligence, which are left-brain activities. It does not measure right-brain intelligences. It leaves out one-half of the brain! How smart is that?

The IQ **is** one component of who we are. We all admire the Nobel Prize winner, the genius. We also know that one can be brilliant on the IQ scale and otherwise inept. The IQ does not measure social skills, for example. That's why, to me, the "I" in IQ now stands for "Intellectual," not our total "Intelligence."

EQ
Emotional
Intelligence

EQ or EI = Emotional Intelligence

Emotional Intelligence is "being aware that emotions can drive our behavior and impact people (positively and negatively) and learning how to manage those emotions—both our own and others—especially when we are under pressure." [1]

EQ people tend to take initiative, commit, and pursue goals. They have leadership skills and better job performance. People with strong Emotional Intelligence have excellent social skills because they recognize and understand feelings, communicate well, have empathy and react appropriately. They are able to resolve conflict through problem solving while guiding others. This is huge in today's "Real World."

Daniel Goleman popularized this concept in his 1995 book "Emotional Intelligence." [2] Also known as EQ or EI, it has taken off to the point where you can now easily find and take free EQ tests online. Try taking an EQ test for fun!

CQ
Creative
Intelligence

Acknowledging Your Creative Intelligence

Creative Intelligence (CQ or CI) includes Intuition, Visual and Kinesthetic abilities. Bruce Nussbaum, the author of *Creative Intelligence*[3] says "We are taught that [creativity is] this rare, random thing reserved for 'special' brains. That is a false notion of creativity: **We are all born creative** and can easily learn to be more so."

Art For All Ages is about exploring the creative process through visual arts. Seeing anew what is before us brings insight. Understanding what we see and learning to communicate it (AKA Visual Literacy) is an increasingly valuable skill. It's also what it means to be literate in the digital age.

We shouldn't be afraid to say we are creative or to explore our creative abilities. Creativity involves decision making, thinking outside the box, questioning, brainstorming and problem solving. Being creative is not limited to the visual arts and aesthetic judgment. Entrepreneurial start-ups involve creative engineering, quality design and divergent thinking that is nonlinear and spontaneous.

How important is measuring CQ? If anyone is creative, it is Stephen Spielberg. Yet Spielberg did not get into USC School of Cinematic Arts because of a "C" average in high school. Standardized testing only measured his quantitative mathematical and verbal skills. Additional assessment of other strengths would hopefully identify such a talented candidate today.

Learning Style

How do you take in the world?

Your Multiple Intelligences

Following up on the left-brain/right brain research, Howard Gardner,[4,5] originally identified seven distinct intelligences. Gardner, a developmental psychologist, questioned the premise of intelligence as measured by the IQ test alone. He believed no one is limited to just one learning style. Gardner saw our innate abilities as ways of knowing our world.

His ideas were revolutionary at the time he developed them. They have profound implications for how we understand our world.

A Self-Assessment

The chart below shows the original seven distinct intelligences that Gardner identified. To determine your strengths, consider, "How do I learn best?" Without being limited to one answer, find your varied intelligences in the following chart.

Multiple Intelligences / Learning Styles	How do you fit in each category? List your strengths.
1) Logical / Mathematical – *(numbers/reasoning smart)* Are you good at tests? Do you think conceptually? Are you able to see and explore patterns? Do you think in an ABC Linear mode and solve puzzles? For example, having logic is mandatory for a scientist, a lawyer or professor. (The outstanding ones are wildly clever and creative, too.)	
2) Verbal / Linguistic – *(word smart)* Do you like words, poems, languages? Do reading & writing come easy for you? I want to know the people who use BIG words. We are a highly verbal society and should absorb every possible word treasure. Let's read books now and look up new words daily. Absorb every word treasure.	
3) Visual / Spatial – *(picture/distance smart)* Do you learn through images, illustrations and multimedia? Do you pay attention to your environment and surroundings? How well can you visualize something? Everyone who drives a car is challenged by visual/spatial relationships. Athletes have to know distance & size in relation to the whole.	

Multiple Intelligences / Learning Styles	How do you fit in each category? List your strengths.
4) Body / Kinesthetic – *(body smart)* Do you love to dance? Do you engage with the world through movement? Your body has its own language. Hands-on and role-play experiences help us acquire knowledge. Do you have good hand/eye coordination? Do you feel, smell and touch things to understand them better?	
5) Musical /Rhythmic – *(sound/rhythm smart)* Do you love to sing or play an instrument? Are you good at remembering sounds and tones? Can you feel music? Sound opens our world. If only the Temptations' lyrics had been changed to help me with chemistry class! What's better than hearing an old favorite song and feeling like you did back then? Go ahead, Emote. Feel the Rhythm!	
6) *Inter*personal – *(people smart)* Do you have good social skills? Are you good at reading people? Do you relate well to others? These people are good communicators. They often enjoy discussion and constructive disagreement. Emotional intelligence? Yes, they've got it! How do you measure empathy and the ability to relate to all people? These people have it!	
7) *Intra*personal – *(self-smart)* How well do you understand yourself? How self-aware are you? These people are reflective and self-aware, clearly introspective. They're independent learners who understand themselves and are intuitive, self-motivated and confident, often with wisdom about their strengths and weaknesses.	

From My Experience

We are multi-dimensional beings, with all the above talents—albeit in differing amounts.

Our best teachers have always known that students learn in different ways. To get inside the heads of students, whatever their age, let's present information in varied ways, so that students can actually take it in, understand and comprehend it.

Today's students are encouraged to take initiative and ask questions before answers are given to them point-blank. That way they develop their full potential to make decisions and problem-solve, skills that will serve them now and in the future.

Did you have a teacher or adult mentor or friend who appreciated you, respected you, connected with you, and allowed you to go to your highest level? Please remember and celebrate that relationship.

Personality Type

How do you interact, make decisions?

Our Unique Personality

How do you approach the world, interact, make decisions, and get information?

The "Myers-Briggs" personality test has been around since the 1940s.[6] The test measures cognitive skills and the learning preferences that we've been looking at. The assessment is a popular tool with businesses, who use it in hiring and personnel development. Individuals use it to help guide them to the careers they are most suited for.

The Myers–Briggs Type Indicator® test ("MBTI") is based on Carl Jung's eight psychological types. The questionnaire has about 100 "forced-choice" questions and takes around 30 minutes to complete. "Forced-choice" means that you have to choose between two alternative answers, neither of which may be exactly right.

When the test is scored the result is a 4-letter code. These four letters are the shorthand for your Myers-Briggs personality type.

I took the test at age 30 from a career counselor who walked me through 20+ pages of information about my personality type. My 4-letter type was ENFP, which means I scored higher in their Extraverted, Intuitive, Feeling and Perceiving categories.

These days some psychologists and testing professionals consider the test to be a little too "black and white." Personally, I'd like to think our personalities cannot be defined by four letters. However, the test did help me find out more about myself and what careers I was more suited for, and it has helped many, many others over the years.

Clearly it helps to have a professional interpret the test results. That said, you can now take free Myers-Briggs sorts of tests online. If you are interested, you can get a feel for what your results mean on the websites where you take the test.

Below is a brief self-assessment using the 8 Meyers-Briggs categories. Where do you find yourself in each category? Take your time. As with the Myers-Briggs test, you must choose only one of the two alternatives provided. Even if neither is exactly right, choose the one that's describes you better than the other.

Write down your choices. When complete, you'll have a 4-letter summary of your "type." These four letters are the shorthand for your personality type.

To interpret the results, search "interpreting Myers-Briggs results" on the internet.

A Brief Personality Test The Four Big Questions	For each question, which of the two choices defines you more?
How do you prefer to interact with the world? • **I Introvert** – Prefers working alone or in small groups • **E Extrovert** – Energized by people, multi-tasks, quick pace	
How do you prefer to take in information? • **N Intuitive** – Innovative, creative solutions, understands the big picture, takes in multiple possibilities. • **S Sensing** – Practical, focuses on tangible facts and details. Tends to distrust hunches.	

| A Brief Personality Test | For each question, which of the |
The Four Big Questions	two choices defines you more?
How do you make decisions? • **F Feeler** – Based on personal values and how others are affected • **T Thinker** – Objective, consistent, fair, weighs logical pros and cons	
How do you approach the world? • **J Judgmental** – Prepared, organized, rule follower, makes plans • **P Perceptive** – Spontaneous, flexible, likes to improvise	

If you are a soul searcher or want to look at yourself in more depth, I suggest that you look into Enneagrams. *Ennéa*, in Greek, means 9. I appreciate the focus on spirituality, and self-development that the Enneagram offers.

Conclusion

Sometimes we can feel "stuck" with labels about ourselves that we picked up somehow, somewhere in our life journey. From my years teaching art (and while interviewing adults for this book) I know that many adults feel frozen in the "I can't draw a straight-line" mode. If you feel like that, I hope that this section has opened you to an enriched sense of who you are, and who you can be.

Making art as described in this book can bring with it a wonderful experience of reconnection, wonder and joy. Don't get stuck in old messages or labels that don't serve you. Find your artistic, creative self as you do the **Recipes for Success** activities in *Art For All Ages*. We all have the ability to pursue new interests. Click your heels and jump into a new you.

1. "What Is Emotional Intelligence, Daniel Goleman." IHHP. Accessed July 03, 2019. http://www.ihhp.com/meaning-of-emotional-intelligence.

2. Goleman, Daniel. Emotional Intelligence. New York, NY: Bantam Books, 1995.

3. Nussbaum, Bruce. Creative Intelligence. New York, NY: HarperCollins Publishers, 2013.

4. Howard Earl Gardner (born July 11, 1943) is an American developmental psychologist and Professor of Cognition and Education at the Harvard Graduate School of Education, Harvard University.

5. Gardner, Howard. Frames of Mind: The Theory of Multiple Intelligences. New York, NY: Basic Books, 1983.

6. The MBTI® test (Myers-Briggs Type Indicator® Assessment) was founded and created by the contributions and research of a mother-daughter team by the name of Katharine Cook Briggs and Isabel Briggs Myers, respectively.

CHAPTER 10

THE MAGIC OF AGING
The next chapter, whether you are 40, 60, or 80 plus...

Whatever your age, now is the time to get to your creative best. By yourself, with friends or a child, delve into the regenerative experiences found in *Art For All Ages*. I promise you that doing any of the **Recipes for Success** activities in this book will be fun. And there are health benefits.

Research shows that creative expression through the arts is therapeutic. Dr. Gene Cohen established a direct link between creativity and health in his book, *The Creative Age: Awakening Human Potential in the Second Half of Life*.[1] He states, "Creative expression is essential to healthy living." I thank his wife, Wendy Miller, for a phone call in which she shared his and her insights.

I have had the privilege of teaching art for 35 years. In that time, I have taught budding artists from ages 4 to 95!

All ages have a need for creative expression. Appreciate the creative process. Join in the journey. "Click your heels," choose a **Recipe for Success** activity, and the Wizard will take you where you want to go.

Retirement

This hopefully means travel, no alarm clock and not knowing what day it is or worrying if you have enough money for the coming years.

There can be a lot of **soul searching during this transitional time**.

We get to an age where we can be free spirited again. We have fulfilled obligations professionally, socially and to family. So... **NOW WHAT?** Time to ourselves... for what? To be self-indulgent and follow new passions?

Some of us are old enough to qualify for cheaper movie tickets, but still fantasize about being in the movies! As "seniors" with grandbabies, we can still feel in our 20s until we look in the mirror. Don't despair; our dreams are not lost.

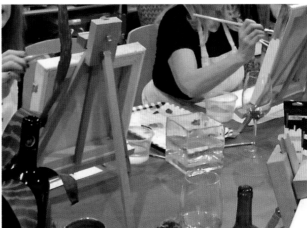

Adult workshop in author's studio

What have you been putting off doing for yourself?

Run. Do not pass go... Do an activity in this book. Collect the joy and peace of re-connecting to yourself as you make art.

Do everything you have put off doing for yourself. Find a local art class. Sing with a group. Join an acting guild. Go to yoga, more often. Walk with a friend. Join a book club, or two. **Grow your brain!**

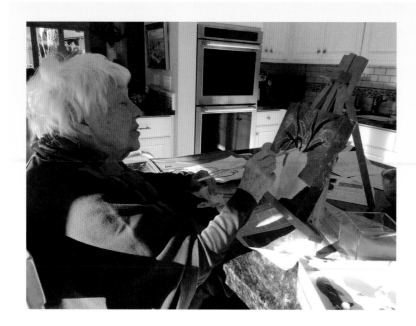

Betty, age 91. Her first drawing and painting lesson in 75 years.

"You kept telling me, 'There are no mistakes in art!'"

My Research and Experience

In 1976, at Stanford University, I did research while teaching art to seniors with differing amounts of dementia. I noticed a definite correlation between the scribbling stages of young children and the same kinesthetic scribbling of the aged, even some who were former artists.

It is imperative to keep the creative spirit intact during any decline or deterioration at this time of life. Working with the aged, time and time again, while making art, they told me stories from the past to explain what they were expressing in their art.

To clarify, I had no knowledge of what kind of dementia my seniors had (be it vascular, frontal lobe, or Alzheimer's). In fact, this was long before the "Alzheimer's" label. Nor am I an expert in brain pathology. I did however know that expression through the arts was a vehicle for continued growth.

Geriatric care involves the humor of the caregivers, the emotional support of family, and our senior centers providing fun and creative experiences for those with age-related decline or mild cognitive impairment such as dementia.

I am intrigued and will continue to pursue my belief that our maturing senior brains can continue to grow and absorb knowledge. I believe our imagination is intact until the day we die, no matter how severe the degenerative process is.

And the same truth needs to be told:

There are no mistakes in art!
You can master new creative skills at any age.

GO TO A MUSEUM. TALK ABOUT THE ART.
GO TO A CONCERT,
BE IT ROCK AND ROLL, JAZZ OR CLASSICAL.
HOW DOES MUSIC MAKE YOU FEEL?
GO TO A PLAY, THE MOVIES, OR THE BALLET.
COLLECT ART. MAKE ART.
WHAT DO YOU FEEL?
GO SEE THE SUNSET, FEEL THE
TEMPERATURE.
LISTEN.
ART IS SURROUNDING YOU.
OBSERVE.
STRETCH YOUR CREATIVITY.

I highly recommend you watch the documentary, *I Remember Better When I Paint, Treating Alzheimer's Through the Creative Arts*.[2]

Another resource is The National Center for Creative Aging (CreativeAging.org). NCCA is "dedicated to fostering an understanding of the vital the relationship between creative expression and healthy aging and developing programs that build upon this understanding."[3]

Together with The National Endowment for the Arts, The National Center for Creative Aging is dedicated to bringing arts programs to communities, senior centers, adult day care, and assisted living throughout the country because "Community Based Arts Program Improve Quality of Life."[4]

1. Cohen, Gene D. *The Creative Age: Awakening Human Potential in the Second Half of Life*. New York: HarperCollins Publishers, 2001.

2. *I Remember Better When I Paint*. Accessed January 21, 2019. http://www.irememberbetterwhenIpaint.com/.

3. "Our Mission." Creative Aging NCCA. Accessed September 02, 2018. http://www.creativeaging.org/.

4. "Creativity & Aging." National Endowment for the Arts. August 24, 2017. Accessed March 08, 2019. https://www.arts.gov/accessibility/accessibility-resources/creativity-aging.

Supplies List

Start with a **sketchbook,** often referred to as an art journal. Collect photos. Write thoughts and quotes. Sketch when you have time, a place, and an idea.

You don't need to spend a lot of money for the basics. By subscribing to and ordering from an online art supplies store you are likely to benefit from discounts, sales and coupons, and some offer free shipping with a minimum order. I am a believer of running into your local art stores with or without coupons for the last-minute projects!

THE BASICS

- good, sharp, appropriately sized scissors
- glue stick
- white glue, applied with sponge brush
- #2 pencil
- black water-base markers, thick and thin
- black permanent markers, thick and thin
- colored markers
- black crayon
- gold paint pen, medium

BRUSHES

Brushes you will need for the activities in *Art for All Ages*:

Watercolor and Tempera Brushes

Crayola® or some equivalent camel hair watercolor brush, #10 round, which can be used for both watercolors and tempera.

Add #8 and #12 brushes as needed.

Acrylic Brushes

I like to go and feel brushes. You will want easy to clean and affordable synthetic brushes. A good starter kit would probably include some rounds, a flat, and a filbert in sizes #6 to #12.

PAPER

Construction paper: Tru-Ray® is nice and heavy and comes in a package of 50 pieces, including:

- assorted colors 12" x 18"
- white 12" x 18"

Drawing paper: Strathmore® bristol (300 Series) for drawing; 20 sheets, 11" x 14".

Watercolor paper: Strathmore® watercolor pads of paper. I like to have 18" x 24" and cut it in half or thirds as needed.

Newsprint: 18" x 24".

COLOR MEDIUMS AND PAINT

Oil pastels: Sakura® 25 color Expressionist Oil Pastels. You will need extra black and white.

Watercolors: Prang® semi-moist half pan set of 16 color set watercolors, because you need **primary**, **secondary**, and **tertiary** colors. I usually get extra pan refills of yellow.

Optional: Crayola® watercolor pencils are really fun. These pencils can be applied after dipping them in water, or you can "color" with them and apply water on top with a brush.

Disposable palette pads or paper plates to mix paints on.

Tempera paint: Buy the pint size liquid. (In my early days tempera came in a powder form only).

- You will certainly need the primary colors: red, blue, and lots of yellow
- You will also need: black and white to make tints and shades
- Helpful colors: magenta, and turquoise
- If your budget allows, add the secondary colors: orange, green, and purple (purple is violet)

When painting, never use a color right out of the bottle. Change a bottled color in the slightest way to make it your own color!

Acrylics: Same color options as tempera, above. Use will depend on age. Remember, acrylic is liquid plastic and needs to be washed out of any clothing immediately. You can start with an affordable set. Acrylics dry very quickly, so be sure you never leave brushes in the paint. Clean acrylic brushes well after each use.

NOTE: *Art for All Ages* does not use oil paints because they are toxic. I love oil paints, but prefer to keep the *Art for All Ages* projects NON-toxic.

Colored Chalk: Enjoy a pack of 24.

ODDS & ENDS

Down the line, I would add the following to your supply budget:

Conte pencils: Matchbox set of 4 (natural) sketching colors.

Willow charcoal.

Drawing pencils: various densities, from soft to hard.

Wood figure mannequin for figure drawing.

Utrecht® color wheel guide.

Table-top easel.

Have an abundance of newspapers, paper towels, water containers, paper plates or disposable palette pads, and an apron!

BONUS PAGES

WORD HUNT

Search the book for the following words. Many appear more than once. Then list the page number where you find them. You are creating your own index!

A Artistic, Abstract, Aesthetic _____

B Brain, Balance, Bleed-off _____

C Creativity, Color, Contour, Critique, Cubism _____

D Design, Drawing Skills, Decisions _____

E Elements of Design, Emphasis, Expressionism _____

F Face Recipe, Form, Fauvism _____

G Geometric, Gesture _____

H Horizon Line, Art History _____

I Intelligence, Impressionism, Intuition_____

J Joy, Judgement _____

K Knowledge, Kinesthetic _____

L Line, Learn to Look, Left-Brain_____

M Meditation, Mandala, Monochromatic _____

N Negative Space _____

O Overlap, Observation_____

P Proportion, Perspective, Process, Pattern _____

Q Quiet Right Brain _____

R Realism, Risk, Right-Brain, Reflection _____

S Shape, Space, Sketch, Symbols _____

T Texture, Tint, Transparent _____

U Unity, Universal Language_____

V Visual, Viewfinder, Vanishing Point _____

W Warm Colors / Cool Colors_____

Z Zone, Zoom Lens _____

PAY IT FORWARD

"Pay It Forward" is an expression that means:

Responding to a person's kindness that you received by being kind to someone else.

My Personal Example:

I feel like I am sharing all my secrets to the world through this book. This is my way of paying it forward.

Brainstorming

Take a look at **Chapter 9, Self-Discovery: Who Are You? Who Do You Want to Be?**

Starting with gratitude, appreciate the kindness and generous support you have been given. Pay forward the same goodwill to affect others without asking in any way for repayment.

Share some ways you already "pay it forward."

Consider ways you would like to do so.

PLAN AN ART PARTY
Adult Friends Together

You like the idea of gathering with others to socialize, draw, and paint.

What kind of gathering are you thinking about?

- ☐ Men and women
- ☐ Women with women
- ☐ Men with men

Brainstorming

Take a look at *Chapter 6, Welcome Renaissance Men and Women*.

If you decide to send out invitations for an ART PARTY, who would you invite?

1. _____
2. _____
3. _____
4. _____
5. _____
6. _____

What activity would you do?

Considering the **Recipes for Success** experiences in this book:

What activities would you like to do?

Which would your group enjoy?

Preparing for Your Art Party

See *Chapter 8, Have an Art Party* for invitation ideas and advance preparations.

"I think I would like to invite Vincent Van Gogh, Pablo Picasso, Georgia O'Keeffe, and Jackson Pollack."

PLAN AN ART PARTY
Adults of All Ages with Children

You want to share the joy and childlike wonder of making art.

What kind of gathering are you thinking about?

☐ A grandparent with grandchildren

☐ Parents with children

☐ Children with friends and an adult mentor

☐ Three generations: grandparents, parents and children

Brainstorming

Take a look at **Chapter 1, Where are You on the Artistic Scale?**

If you decide to send out invitations for an ART PARTY, who would you invite?

1. _____
2. _____
3. _____
4. _____
5. _____
6. _____

Which activity would your group like to do?

The **Table of Contents** has symbols that highlight activities particularly suited for children of various age levels. **Use these symbols to easily find activities suitable for your group.**

▲ **Adults, Teens and Upper Elementary:** *Ages 10 and up*

● **Lower Elementary:** *Ages 6-10*

★ **Little Ones:** *Age 5*

NOTE: Most activities can be adjusted for budding artists of all ages. All are suitable for adults.

Preparing for Your Art Party

See **Chapter 8, Have an Art Party** for invitation ideas and advance preparations.

START AN ART CLUB
Time to Reignite your Artistic Self

An ART CLUB, like a book club meets to enjoy collaborative learning on an ongoing basis. Consider a salon gathering or forum of people together with an inspiring host. Aside from enjoying one another, the group will gather to refine skills and visual literacy, while increasing knowledge and artistic balance.

Brainstorming

Who might commit to an ART CLUB to learn new skills while doing the activities in **Art For All Ages**?

What occasional "field trips" might energize the group?

☐ Art Museums

☐ Galleries

☐ Lectures

What strengths can you contribute to the group?

☐ Organizer

☐ Teacher

☐ Your passion for art

☐ Other: (fill in your greatest strength) _____

How often do you want to meet?

When?

Where?

If you decide to form an ART CLUB, who would you include?

Who do you want to share your artistic self with?

1. _____

2. _____

3. _____

4. _____

5. _____

6. _____

Resources

Books to add to your future Library

The Annotated Mona Lisa: A Crash Course in Art History from Prehistoric to Post-Modern
Carol Strickland, Ph.D.

DK Art School: An Introduction to Art Techniques
Ray Smith, Michael Wright, and James Horton.

Drawing on the Right Side of the Brain: A Course in Enhancing Creativity and Artistic Confidence
Betty Edwards

Acknowledgements

My most important treasure, the editor who never stopped believing even when I might have bailed on this project. Thank you, Doug Schaff, solid staff of my soul. I thought I had a great book until you came in with your wisdom to clarify my thoughts, thus making the words exceptional. I appreciate your endless support and brilliant editing. Together, we made this book happen.

Equally important, thank you to my mother and my father, who without a doubt, supported every move I made. Without question, this book is dedicated to you. Thank you for believing in me. Always.

Thank you to my dearest of friends, past, present, and future who supported me through this endeavor. You are my rock, my believers, my heartfelt friends.

I commend my friends who initially edited the 1st draft, for their reflections. You did a great job for me.

Thank you to my lead player in the Kickstarter campaign, Rebecca Ann Jones. You helped me fund the printing and copyright for this book. I am eternally grateful to all of you who financially supported me by backing my Kickstarter campaign.

I am thrilled that so many of you came together for a cause; the lust for the Arts, revived.

Finally, I give praise to the woman, designer, perfectionist, Teri Rider. Thank you for your talent in making this book stunning in spite of multiple changes along the way. Your design skills are creative and savvy. It has been a pleasure working with such a skilled professional.

With Gratitude, Thank you all.

What a team!

Corinne Miller Schaff

Thank you for Reading!

Dear Reader,

I hope you enjoyed *Art For All Ages*, and that you will come back again and again to try new activities. Please share the book with your friends and family.

I am very excited about this book and what it means for you. I would enjoy hearing your thoughts and getting feedback about the book and your art experiences. You are welcome to write me at the address below. Please send photos of the art you create! I may just post some on my website.

Like all authors, I appreciate online reviews to encourage future sales. You, the reader, have the power to influence others who are browsing for a good art book. In fact, most readers pick their next book because of reviews or the recommendation of a friend. Please take a few moments now to share your assessment of my book on Amazon, Goodreads or any other book review website you prefer.

Thank you so much for reading *Art For All Ages*. If you are inclined, please visit my website and social media pages to learn more about making art in the *Art For All Ages* way. It's about the experience. Click your heals and jump into the *Pizazz of your Heart!*

Corinne Miller Schaff

Corinne Miller Schaff

CoriArt4All@gmail.com
Art4all.me
facebook: @artforallagesthebook
Instagram: #artforallagesthebook

702.8 S296

Schaff, Corinne Miller,

Art for all ages:

01/21

FLT